DIY Temporary Tattoos

Draw It, Print It, Ink It

www.stmartins.com

Copyright © 2016 RotoVision SA
www.rotovision.com

The written instructions, photographs, designs, patterns, and
projects in this volume are intended for personal use of the
reader and may be reproduced for that purpose only.

Library of Congress Cataloging-in-Publication Data Available
Upon Request

ISBN 978-1-250-08770-6

Our books may be purchased in bulk for promotional,
educational, or business use. Please contact your local
bookseller or the Macmillan Corporate and Premium Sales
Department at 1-800-221-7945, extension 5442, or by e-mail
at MacmillanSpecialMarkets@macmillan.com.

First U.S. Edition: April 2016

10 9 8 7 6 5 4 3 2 1

Publisher: Mark Searle
Editorial Director: Isheeta Mustafi
Commissioning Editor: Alison Morris
Editor: Emma Hill
Junior Editor: Abbie Sharman
Art Director: Michelle Rowlandson
Design concept: Agata Rybicka
Book layout: JC Lanaway
Photographer: Matthew Willmann
Cover design: Agata Rybicka

Printed and bound in China

Safety

When choosing your tattoo transfer paper, it's
important to select only high quality paper that
meets the safety standards in your country. These
safety standards usually mean that both the safety
of the adhesive itself, as well as how effectively the
paper keeps the ink from your printer sandwiched
between the adhesive and top film, and away from
your skin, have been tested.

While a reaction is unlikely, if you have sensitive
skin it's a good idea to try a small tattoo first so
it's easy to remove if you have any skin
sensitivity. Avoid placing your tattoo on areas of
very thin skin, or any broken or inflamed areas.

Tattoo pens are usually tested to meet
requirements for cosmetics, and should not have
any adverse effects on your skin. Avoid using
regular pens or permanent markers on your skin.

Your skin cannot "breathe" beneath tattoo
transfers, so it's best to avoid covering a large
portion of your body at once. Give your skin a
chance to recover and breathe for a day or so
between tattoo applications.

Always follow the manufacturer's instructions
on your tattoo transfer paper or tattoo pens.

DIY Temporary Tattoos

Draw It, Print It, Ink It

Pepper
Baldwin

ST. MARTIN'S GRIFFIN
NEW YORK

Acknowledgments

Firstly a squillion thanks to the artists who contributed their wonderful work for the book, you guys inspire me every day and I love working with such a talented bunch! (Check out the artist acknowledgments for artist links and contact info.)

Big thanks to my assistants, past and present, at Pepper Ink temporary tattoos—Chelsea, Anita, Jess, Megan, and Nina—who came along for the ride. Without you guys at my side I wouldn't be here today.

To Isheeta, Emma, and Abbie at RotoVision books–thank you for the opportunity to do this awesome project, and for your support, patience, and just being really lovely people to work with.

Last but definitely not least, thanks to my family for their support, Dave for the coffee and excuses, Ruth for the virtual hugs, and all the people who I'm chuffed to call my friends.

And thanks to you, lover of temporary tattoos; I hope you enjoy this book as much as I enjoyed writing it for you!

Contents

Introduction

For thousands of years we have been decorating our skin to beautify it and communicate meaning. This body art—simple or elaborate, yet always personal—has served many purposes; a mark of status, a statement of religious belief, a declaration of love, to conform, to rebel, or simply to prettify. This urge to wear meaningful symbols and beautiful designs can be seen today in a variety of places—from the doodles scribbled on arms during a long class, to the faces of sports fans painted in a favorite team's colors—and this increase in popularity is reflected in the huge range of temporary tattoo designs that are now widely available. The way we decorate our skin can mean so much, or as little as something pretty to look at; it can be art, a reminder, a battle scar, a social or professional signifier, or simply an individualist expression of what makes us who we are.

Temporary tattoos are fast gaining notoriety as a fun and individual way to express yourself, no matter what your age. The variety of styles, colors, patterns, subjects, and ways to wear them combine in limitless possibilities. Quality specialized tattoo transfer paper is widely available, or you can draw directly onto your skin using specially formulated skin-safe tattoo pens. Designing your own temporary tattoo allows you to personalize a design to mean as much or as little as you like; you can design from scratch incorporating multiple elements into a large piece that has a rich personal narrative, simply trace from the Inspirational Gallery in Chapter 3, or draw freehand. You don't have to be an artist to design your own temporary tattoo, and because it's not permanent you can change your mind and try new designs…again and again!

In this book we'll explore how to create a tattoo with personal meaning; cover tattoo placement, styles, and design tips; then move on to the practicalities of printing your design to wear. You'll find everything you need to know to draw, print, and ink your own temporary tattoo. There are so many options for illustrations, vintage designs, and patterns. You can bring your own ideas and images, or browse the Inspirational Gallery where there are web links and QR codes that allow you to download and print some of the designs. Try reading this book in order, then skip from section to section as you combine your ideas and use your favorite methods to create a truly individual temporary tattoo you'll love.

Let's get started!

Tattoos for you and your friends in 3 easy steps

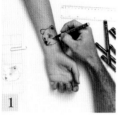

1

Template p117

2

Draw it

Select one of our templates or draw your own! You can use felt tip pens to color in your design and scan or download some of the digital files using the QR codes and links.

Print it

Use your home printer to print your design. Tattoo pens and transfer paper can be purchased on the Internet.

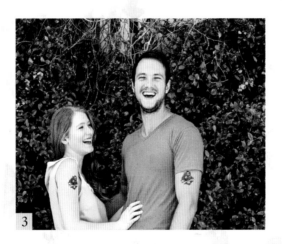
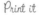

3

Wear it

Cut out your design, remove the plastic layer, and press the paper to the skin. Dampen with water and hold for 20 seconds. Remove the paper and you are ready to show off your latest design.

What Do You Want To Wear?

You can start pretty much anywhere with your temporary tattoo—perhaps you already have an idea for a design, or are looking for something for a particular body part. Maybe you have something in mind for matching tattoos, a style you really love, or already have a picture you'd like to use. Whether you have something in mind already, or you're working with a blank slate, it's a good first step to think about the underlying reason behind your tattoo. What would you like it to mean, and how will you communicate that? A design can be infinitely personalized and made unique, and can communicate a lot about you, what is special to you, and your journey through life.

Finding inspiration

You can gain inspiration from any visual source; permanent tattoos, contemporary artists, book illustrations, nature…anything that makes you stop and admire its beauty or pause for thought. After designing your own tattoo you may start to see everything as a potential tattoo subject!

The meaning, interpretation, and visual effect of a tattoo comes not only from the subject matter, but also from where you wear it, its size, style, colors, and composition. A large tattoo is bold and confident, whereas a small one is more private. Bright colors are outgoing and black line work allows finer detail. Some designs might invite people to step closer to get a better look and appreciate detail, others may be worn as tiny personal marks. Some can be seen all at once, others wrap around body parts in such a way that you have to move to get the full effect.

This section will cover these visual design considerations and will help you to gather resources and preferences to get an idea of what you'd like to create, and how your choices may impact your design. All of the visual elements together will influence your tattoo, so it's helpful to design it holistically and experiment with altering elements to see how it affects the overall design.

There are no fixed steps or right or wrong answers; this is simply a process of deciding on your ingredients before moving on to the next section, where they will be brought together in your design. Depending on where you start, you might find yourself going from one section to another as you adjust your design recipe to create the perfect temporary tattoo you'll love.

BELOW: This bright contemporary floral design is striking as a tattoo sleeve.

Deciding your tattoo subject and design elements

What is your tattoo going to mean to you? What is the subject? If you're considering a pattern or shape, what appeals to you? You may have a finished idea already, or one that you'd like to expand upon. You can either start with this section, or skip ahead—if your tattoo style is more important to you than content, you may want to choose a subject that traditionally suits that style.

A picture speaks a thousand words and every tattoo tells a story. Whether a simple line drawing or a detailed back piece, the images we choose to wear tell of our experiences and reflect our personalities.

Use the prompts on the right to write a list of subjects that are important to you. Write as much as you can—you don't need to combine everything into one tattoo, but it may help you to identify themes that are especially important to you, or subjects you'd particularly like to incorporate into your design. Often multiple ideas can be communicated in a single design; it's simply a matter of using each design element to add meaning. You may have several design ideas for a temporary tattoo, in which case hang on to them and revisit the steps in this section for each one. As you read through this chapter, keep this list and add to it with notes and reference images of your favorite subject matter, designs, and examples.

Commemorate—loved ones, family members, children, pets, favorite places, or times of your life

Celebrate—special relationships, events or milestones, birth dates, anniversaries

Unify—your sports team, subcultures or groups you identify with, someone you'd like to wear matching tattoos with

Communicate—your beliefs, motto, or ideals; narratives about your family or personal history

Beautify—aesthetically gorgeous things you love, body parts where you'd like to wear a tattoo, favorite styles, artwork, or artists

Individualize—words that describe you, your talents and experiences, your favorite colors

Here's another list to illustrate how ideas can be generated through your personal interpretations. Use the prompts below and note down words, images, and subjects that come to mind; many of your associations will be unique to your experience.

Time	Family	Success
Growth	History	Love

Communicating your tattoo meaning

Once you have an idea of what you'd like your tattoo to mean it's time to choose how you want to convey that meaning. It could be as simple as picturing your subject or using text, or more complex by using symbols, personal definitions, and metaphors. You can have an intricate design or a simple symbol— how your idea is represented can be as unique as you are.

Take a look at the lists you've generated from the prompts on the last page and try writing more personal meanings against each of your possible tattoo subjects. You will likely notice you have ideas that can be communicated in more than one way, or an image that communicates more than one idea. Read the meanings given in the Inspirational Gallery later in this book, and do your own research to find subjects that communicate and portray your desired message.

Your subject matter doesn't have to be obvious. Think about using more subtle visual metaphors or similes to represent your idea. Communicating your meaning by combining elements in unexpected or unusual ways can be really effective and result in a truly unique design. Try brainstorming lists of words you associate with your possible tattoo meanings. You could use one of these associated images or elements to suggest your primary meaning, then add secondary elements to either accentuate it or to add more detail and narrative.

Example

From her tattoo subject list, Megan knows she wants a design to commemorate her mother, perhaps incorporating her birth date. She could consider having a tattoo that includes the gemstone or flower associated with that month, the month's horoscope constellation or animal, a constellation or moon phase of that exact date, or a clock face with the date or time shown. She could also choose a favorite animal, child's toy, or symbol of her mother with a date added underneath either on a banner or in roman numerals.

See more on Megan's tattoo design on p40.

Tip

Once you have ideas for subject matter to communicate your meaning, you can search tattoo flash and vintage ephemera websites for images that you may be able to use. See the Resources section on p122.

OPPOSITE: You can wear an arrangement of tattoos in a similar style to make up a larger piece like this tattoo sleeve, or wear a large bold design on its own on a wrist or arm.

ABOVE: Megan's tattoo design pays tribute to her mother.

Placement and size of your tattoo

The placement—or part of your body on which you'd like to wear your design—and its size are the most important components in selecting or designing your tattoo. You'll want to take a few things into consideration when choosing your tattoo placement. How big do you want your design to be? Is it simple or complex? Would you like other people to see it, or is it just for you? Would it be okay if you can't see it without a mirror?

You can start with your body part and design your tattoo to fit it, using appropriate line work so it's easily seen, perhaps designing using the movement of your body such as the bend in your arm. A small music note behind your ear or cello sound holes on your lower back both use the body's shape or senses to great effect. Alternatively, if you have a good idea of the design and size you'd like, you can choose a body part to suit it, keeping in mind the size, shape, and movement of the body part.

Your tattoo will be viewed differently, and therefore invite a different response, depending on where it's positioned and how it directs the gaze. A portrait on your arm looking backward (toward your back, instead of matching your profile) seems awkward, a tattoo wrapping behind your arm can be mysterious, and pointing hands, animal eyes, and sometimes line work can all intentionally direct the viewer's eyes. Designs on the thighs traditionally face away from you so they are the right way up when you're standing. Designs on the wrist or forearm usually face toward you as they are often reminders or hold very personal meaning. Choosing a tiny size in a large space, or an oversized design on a smaller body part, can change how your tattoo is interpreted and can have interesting design connotations.

Size and placement checklist

• Approximate dimensions
• Body part
• Will it be under tight clothes that rub?
• Is the skin stretched a lot (i.e. on a joint)?
• Would you like it to be visible from one angle, or will it wrap around and be partly hidden?

If you're using a computer program during your design stage, you can superimpose your design onto a computer-generated body part or photo of yourself to check sizing and see how it will look. Alternatively, you can trace the outline on tracing paper and hold it up to your body part, or trace the body part area on blank tracing paper and use that size as a parameter for your design.

Of course, you're working with temporary tattoos, so if you're not sure you can create your design in multiple sizes and for multiple body parts, then try them all!

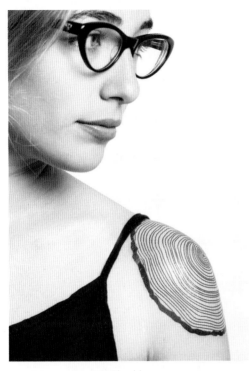

Tip

If your design is going to be in a very round kind of area–like over a shoulder or curving around an elbow–it may work better to print it in several pieces and apply like a jigsaw puzzle. Keep this in mind as you design so that you can create pieces that are easy to cut out and join up again. See the design tips and tricks on p30.

Shoulder

Back

Thigh

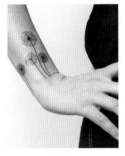

Wrist

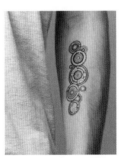

Inner forearm

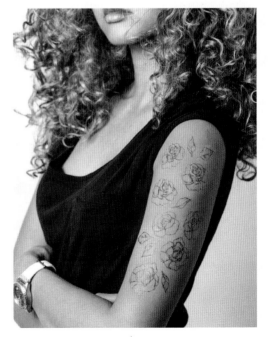

Arm

Fingers

Where to wear your tattoo

1. Upper arm–traditional tattoo placement, can fit larger designs, skin relatively still.

2. Inner upper arm–slightly secretive, great to half-hide a design.

3. Elbows–very flexible skin so difficult to tattoo and hold transfer tattoos. If you'd like to tattoo your elbows you can draw a design using tattoo pens.

4. Full arm–sleeve tattoos suit intricate designs and can incorporate multiple images, usually with a cohesive background.

5. Forearm inner–easily seen by you and others, skin is not very flexible.

6. Forearm outer–good for script, more difficult to see it yourself.

7. Wrists–popular placement, suit small simple designs, easily seen. Avoid if you wear tight cuffs.

8. Hands & fingers–very flexible skin, hard to hide, edge of hand is a striking position. Letters or simple designs on one or more knuckles (in between the finger joints) can spell out a word.

9. Face–very visible, be careful of sensitive thin skin when using temporary tattoos. Can suit very small designs.

10. Back of neck–suits small designs, can combine with back piece, hard to see it yourself without a mirror.

11. Throat–very visible, difficult for temporary transfers because of the flexible skin and the design may appear warped depending on angle of your head.

12. Collarbone–suits large, flowing pieces or small designs, not very flexible so temporary tattoos last longer.

13. Chest–suits large pieces with symmetry, or designs that flow from one side to the other–can combine with arm pieces.

14. Ribcage–suits small or large designs, can be hard to see. Be aware of rubbing clothes that will shorten the life of your temporary tattoo.

15. Lower stomach–suits large symmetrical or small designs, flexible skin can change the design over time.

16. Thighs–large space ideal for portraits or big pieces, often in oval shapes.

17. Calves–medium to large pieces suit the back of calves, may need to shave leg hair to apply tattoo.

18. Ankles– small, delicate designs can be used here.

19. Feet–suit small designs, text, or matching designs on both feet.

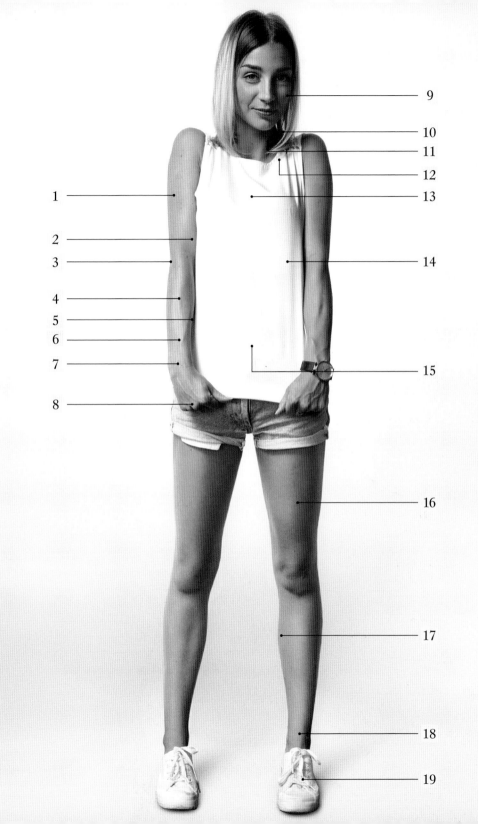

Choosing a tattoo style

Your tattoo style relates to the illustrative techniques used in your design, the way the lines are formed, the colors and shading, and the overall feel of the tattoo. While for the most part your decisions here ought to be about what you totally love, you should also take into account what will work best both with your subject matter and the body part on which you'd like to wear your tattoo. Some styles are more detail oriented and will work better with large designs across a back or thigh, while others lend themselves to simple lines and little or no color.

Tattoo styles are often conventionally linked to a tattoo subject through the culture where they originated, such as the Traditional American style depicting roses, daggers, and pinup girls, or Traditional Japanese style depicting koi and dragons. To help differentiate between style and subject, we'll illustrate the same subject matter in a variety of styles. This way you can really see how the style guidelines communicate the same subject matter in strikingly different ways.

As tattooing comes to encompass more techniques and styles—no longer limited to traditional line work and color palettes—so the design possibilities have expanded to incorporate many fine art techniques and contemporary art styles. Temporary tattooing is even less bound by these limitations and can achieve effects that permanent tattooing cannot—but if you'd like a "realistic" tattoo effect, keep these limitations in mind. Make a note of the styles that appeal to you and those that will suit the complexity and placement of your tattoo, and you can experiment with mixing styles and techniques.

Sometimes a design can incorporate more than one style or technique, or fall outside of traditional or contemporary styles altogether; this isn't intended to be a comprehensive style guide but rather an outline of some traditional and contemporary styles to think about. If you research tattoo designs and artists you'll come across many, many more!

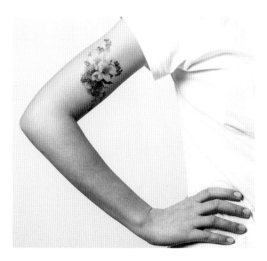

LEFT: A classic vintage floral design makes a pretty tattoo.

American Traditional & Neo-traditional

American Traditional tattoos are recognizable by their bold black outlines and solid color fill in primary colors, in part stylized by early Western tattooing technique and color availability. A signature style of tattooist Norman "Sailor Jerry" Collins in the 1930s, the subject matter was usually skulls, daggers, nautical, and pinup girls—all common motifs for the sailors who were keen to get tattoos for good luck or to commemorate voyages and ports. Neo-traditional uses the same conventional bold outlines and colors but introduces more complexity, realism, other subject matters (such as women and personified animals), and additional elements to make the style more contemporary. Vintage flash is often American Traditional, and modern tattoos inspired by this style tend to be classified as Neo-traditional.

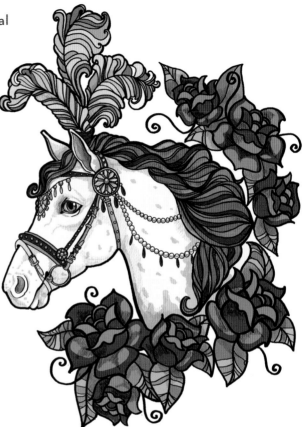

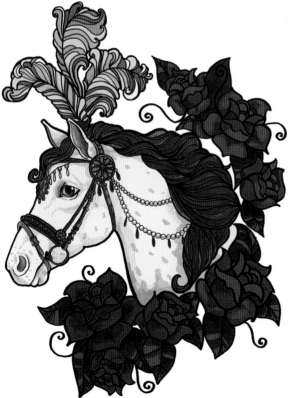

Neo-traditional horses with different color treatment

Notes

There are more examples of illustrative styles in the Inspirational Gallery in Chapter 3.

Illustrative

Illustrative tattoos typically feature the clear outlines and intense color of traditional tattoos but with more realistic shading and an illustrative quality. Similar to Neo-traditional tattoos, but even more illustrative and with a wider palette. This style first appeared when the tools and techniques of tattooing progressed to enable artists to create more detailed lines and use shading techniques to give their tattoos increased depth and a greater range of color.

Illustrative

Sketch work

Sketch work has a rough aesthetic and usually consists of unfinished line work with unclear boundaries, reminiscent of an artist's sketch. This is a contemporary style mimicking art and is often uncolored or semi-colored. Sketch work in contemporary tattoo art is often combined with geometric and watercolor effects.

Sketch work

Traditional Japanese & Neo-Japanese

Traditional Japanese tattooing is based on bold black outlines, minimal shading, and characteristically pictures Japanese art, folklore, and natural motifs such as the koi, lotus flowers, tigers, warriors, and waves. It uses particular details and patterns to represent water, waves, wind, and air. Like American Traditional, the colors and outlines were influenced by the tattooing technique used at the time. It was popularized in Japan by the Japanese criminal underworld. This style, with its bright colors and complex detail and patterns, is well suited to large areas such as the back, chest, arms, or legs. Also like Neo-traditional, Neo-Japanese takes the structure and key elements of Traditional Japanese design and adds contemporary color and shading for a deeper and more three-dimensional result.

Traditional Japanese

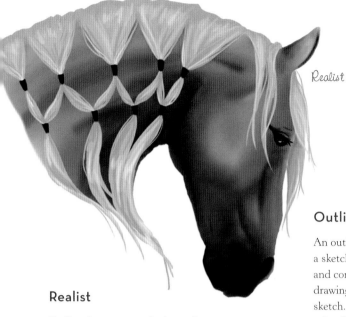

Realist

Realist

Realism is a tattoo style that strives to create as realistic an effect as possible. Often taken from photographs, this style utilizes ranges of colors, careful shading, and natural outlines to render a realistic result. Often used to depict animals and for portraits, realistic tattoos require a practiced hand and great skill. Realism tattoos can be combined quite successfully with other tattoo styles to create unique compositions.

Outline/doodle

An outline or doodle style design is similar to a sketch style but with more finished outlines and complete lines—like a complete pen drawing rather than an unfinished pencil sketch. Usually with black outlines and no color fill or shading, outlines suit simple subjects and small areas as they are clear and uncomplicated. Colored or uncolored cartoons can be considered this style. It is also ideal for hand drawing, tracing, or drawing freehand with tattoo pens. As tattooing styles become broader and more diverse, outline styles will become less conventional and can in themselves add layers of additional meaning.

Outline

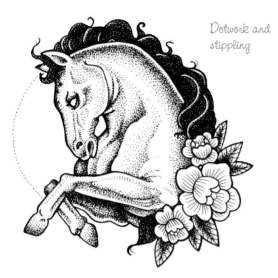

Dotwork and stippling

Dotwork and stippling refers to a method of shading that uses many tiny black dots rather than continuous fill. An intricate and very effective style, it can be seen both in vintage illustration and contemporary geometric design. Dotwork is usually exclusively undertaken in black and white, and typically lends depth to figures and objects. Because of its fine detail, dotwork and stippling suits medium to large sizes, where a variety of line thicknesses and patterns can be achieved. Like realism it can be very effective when combined with other tattoo styles.

Watercolor

Watercolor is an interesting modern style that mimics a watercolor paint wash, brushstroke, or splatter and often showcases beautiful colors. Watercolor effects are usually combined with a dark outline or partly outlined design, but can also be found as a stand-alone style with no outlines. The introduction of white ink has facilitated this budding style, enabling tattoo artists to create pastel shades that are more visible on the skin. Combining well with other styles, watercolor is suitable for small or large designs, although medium to large designs can be more effective.

Watercolor

Tip

Pastel colors and white in transfer temporary tattoos will be affected by your skin tone when worn—see the design tips and tricks on p31.

Abstract

Like the art movement of the same name, abstract tattoo designs communicate a subject or meaning using abstract forms and shapes in a disjointed way—implying meaning or showing parts of a subject in a composition rather than reproducing its likeness directly. Using an abstract style for your tattoo design, or adding elements or additional meanings using abstract style, can result in a strikingly individual tattoo.

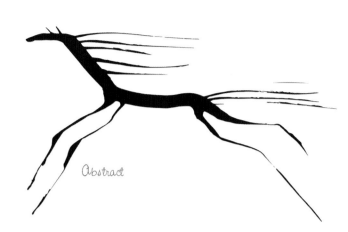

Abstract

Geometric

Geometric

The geometric style is identified by the inclusion of geometric shapes within or behind a design, often triangles, diamonds, circles, or radiating lines. Very striking when paired with dotwork or stippling shading techniques and in one color only, but can also be used with bright color and tonal shading. Subject matter varies but it suits vintage gypsy-like motifs such as the all-seeing eye, animals, hands, and mystical symbols. A contemporary and popular style that can have the level of detail adjusted to suit any size.

Multimedia

Multimedia refers to the practice of creating an artwork by combining, layering, or juxtaposing several types of media or materials. In a tattoo, this kind of effect can be achieved by using different styles, colors, and patterns within one design, or can mimic real-life multimedia by incorporating illustrations of the same style while also depicting newsprint and different textures within the composition. Not for the fainthearted, this style requires care to ensure that the end result is cohesive and doesn't end up muddy or jumbled. Multimedia is an effective way to communicate multiple meanings through a single design, as each texture or media can be rich with symbolism. This style suits medium designs large enough to allow fine detail but not so large that the eye can't take in the entire composition at once.

Multimedia

Tattoo flash

Tattoo flash refers to ready-made designs customarily found on the walls of tattooists' studios for customers to choose from or use as a reference for their own designs. Flash tattoo websites now contain hundreds, even thousands, of designs ready to print or take to a tattooist, and there is also a plethora of flash tattoo art books and design guides. Flash tattoo art is generally limited in style and content to American Traditional simple designs like tribal, pinups, dragons, skulls, and butterflies–anything widely recognized as a "tattoo design"–and is created to appeal to a wide audience.

Flash tattoos from websites are usually ready to print, so they are great for temporary tattoos and experimenting with a particular style or size. Looking through flash designs can provide inspiration for style, size, and coloring for a design that you're envisioning, and you can also use a flash tattoo design as the basis for, or as a component in, your own customized design. Add your favorite flash designs to your reference images.

It's important to recognize that flash tattoo art is the work of an artist and you need to use it with care. Usually designs from a flash tattoo website are available for personal use, but if you find designs on art-sharing sites or elsewhere on the internet it's a good idea to seek permission from the artist to use their design for your tattoo. In most cases artists will be glad you like their design enough to wear it and will be happy to oblige!

Tip
See Tattoo Inspiration & Flash in the Resources section at the back of this book for a list of websites to get you started.

RIGHT: Flash tattoos are often found on the walls of tattooists' studios for customers to choose from or to provide inspiration.

Vintage designs

Vintage designs are illustrations or images from the past, usually utilizing a handful of illustrative styles and techniques, including line work, dotwork, and sketches. Vintage images can be ready to print, or need only slight changes such as removing a background. They make wonderful temporary tattoo designs, style guides, or components for your own design. You can find vintage images in old books–including medical or botanical textbooks and encyclopedias–or as paper ephemera such as postcards or Valentine's cards. Scrapbooking websites and blogs often source and scan vintage images and make them available to use.

Tip

Designs have a copyright date afterwhich they are considered in the public domain and are available to use for personal or business use without permission. Rights to vintage images vary from country to country, so check your country's definition under copyright law.

See vintage designs and vintage-inspired designs in the Inspirational Gallery in Chapter 3.

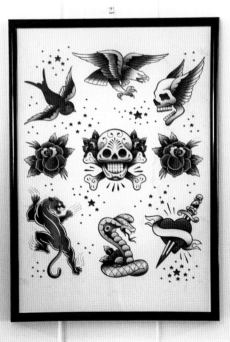

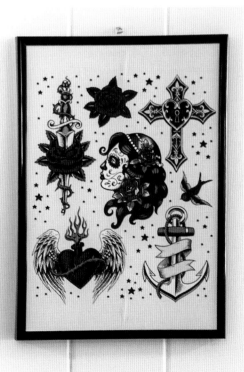

Design tips and tricks

There are a few things to keep in mind as you start constructing your design using your chosen subject matter, illustrative style, and placement considerations. This section will cover some design limitations and strengths of tattoos and temporary tattoos–it's handy to know the limitations of tattoo design and temporary tattoos and work with them to create the best outcome. Many tips for tattoos are also relevant for temporary tattoos, as they relate to how a design is visible on skin. Keep in mind that rules are made to be broken–once you're aware of why designs usually follow these guidelines, you can feel free to use them (or not) to create effects all your own!

Designing for a temporary tattoo

White ink

If you're printing or tracing your temporary tattoo at home, your tattoo won't have white ink–any areas of white within your design will appear clear in the temporary tattoo and skin colored when applied. If you'd like to try out white ink in your DIY tattoo, you can purchase white body paint or a white tattoo pen and color in the design.

Metallic ink

Metallic temporary tattoos use a foil layer to achieve the shiny metallic finish and, like white ink, any area of your tattoo with metallic effects won't be replicated when printed from your home printer. If you'd like to use metallic finishes on your design you can purchase a gold tattoo pen, or a metallic body art pen or body paint, and color in the gold, bronze, or silver areas by hand after applying your temporary tattoo (see the Resources section at the back of the book for links and recommendations).

Black ink

Large areas of solid color in your tattoo will create a layer of unbroken ink that can't expand, contract, or move easily and is therefore more susceptible to crack and wrinkle, especially on more flexible skin. With light colors a crack or wrinkle is difficult to see, but if you're using a lot of dark or black ink in an area be aware that it may develop visible cracking when worn. Try to either use areas of lighter ink or ensure there are "breaks" such as white lines through the black to let the ink flex.

Tip

There are a variety of desktop printers and how the ink prints can vary depending on if you are using a laser printer or an inkjet printer. Read more about this on p50.

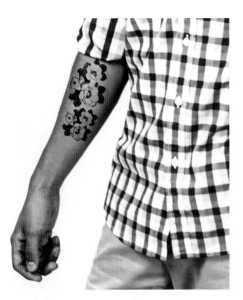

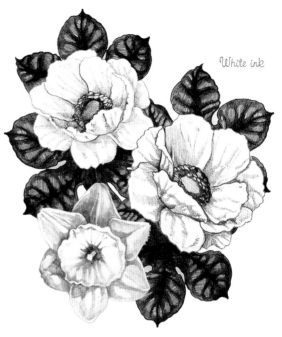

White ink

Any areas of white in your tattoo will appear skin colored when applied.

Black ink

This tattoo uses a large area of black ink but contains white breaks to help prevent cracking.

Tattoo size

DIY tattoo transfer paper commonly comes in an A4 or letter size, about 8 x 12 inches (20 x 30 cm). If you are planning on a design larger than this, you'll need to design it so it can be printed on several pages, cut out, and applied like a jigsaw puzzle. This can also help the design to be more flexible on the skin and prevent cracks in large pieces. If you're using tattoo pens you can make it as big as you like!

Lines

Thick lines are more visible: Over time, tattoo ink disperses slightly under the skin and appears blurry, so traditionally tattoos use thick bold outlines to ensure the design stands out clearly and remains legible as it ages. Even if you only plan on wearing your design as a temporary tattoo, thick lines will help your design look clear from a distance and more like a real tattoo.

Use thin lines carefully: Thin lines work better in dainty or simple designs without too much detail, or in more intricate designs without color. Sizing is important when using thin lines, and those that are too thin may blur to a gray shade at a distance. You can use thin lines as part of an illustrative style, like in crosshatch shading, or to build up color softly rather than using a block of color.

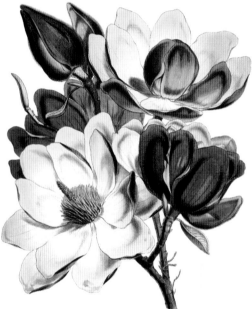

LEFT AND BELOW: This floral design is to be used at a large size so it will be cut out and applied like a jigsaw.

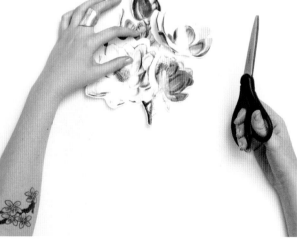

Tip

If you're interested in getting your design tattooed for real after you try it out, and would like fine lines, find a tattooist that specializes in fine line work.

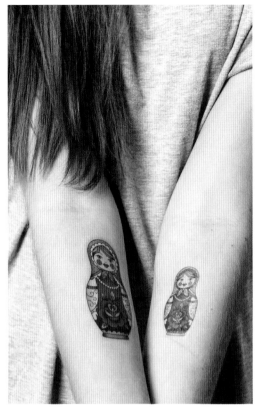

Traditional tattoos use thick outlines to make the design really stand out.

Size

The size of your tattoo will affect how much detail can be seen in your design. You'll want to ensure that your tattoo is comprehensible and doesn't just appear as a multicolored blob to anyone standing a short distance away, which can happen if a design contains too much detail within a small area. It's a good idea to design or draw your tattoo in the size it will be worn, and practice viewing it from a distance. Small sizes suit simple designs, whereas medium and large designs can carry more detail. Keep in mind, though, that very little detail in a large area can result in a striking minimalistic design.

Color

You may need to consider your skin color when working with tattoo transfer papers or tattoo pens, as the ink on your skin won't be completely opaque so your skin tone will alter the color. Darker toned skin may require darker colors and lines to be sufficiently visible. Also be aware that large areas of red or purple without other colors and distinct line work can look like an injury or bruise.

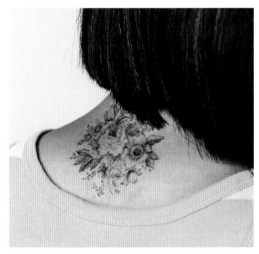

Thin lines work well within this dainty floral design.

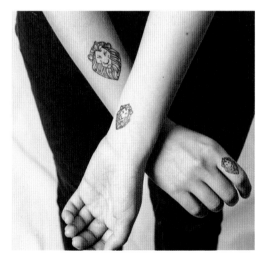

The size of your tattoo dictates how much detail will be visible.

2

Creating Your Temporary Tattoo

By now you should have a good idea of which styles you like, placement ideas, and perhaps your tattoo meaning and subject pinned down. In this chapter we'll cover the different methods that you can use to customize and create your design and wear it as a temporary tattoo. You can draw it entirely freehand, trace reference or inspirational pictures, or use computer design software; or a combination of all three.

You can print your design on specialty temporary tattoo paper to wear, or use tattoo pens and draw directly onto your skin. You can find out more about the tools and materials available to use in the Resources section at the back of this book. The method which best suits you will depend on your preferred skills and the materials you have access to, but whichever you choose, this is the exciting part where you start turning your ideas into an amazing temporary tattoo!

Print out any reference images you've found and make notes on them so you remember which particular aspects appealed to you. For example, you may have an image you'd like to use for the main component, a reference for the kind of border you'd like, and another for the colors to use. By now you could have a style you love, a photo of a pet, your favorite flowers, and a placement idea… plus much more. Use the checklist below to go through the previous chapter and note down your preferences. This will help you to compile all the elements of your design, ready to draw, customize, or trace.

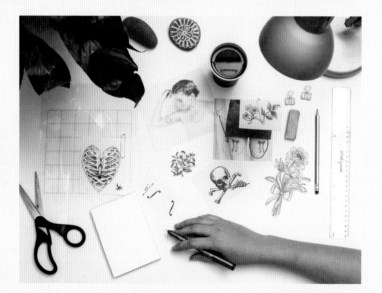

Design checklist

- Meaning or narrative
- Content or subject
- Style or styles
- Color palette
- Placement and size
- Reference photos and images
- Flash and vintage images

Using an artist

If you have a very complex design or need a slight change to an existing design, have an image that's almost there, or are not confident in your drawing skills, you can find an artist to create your design. Choose an artist skilled in the style that you would like your tattoo in, and be sure to give them plenty of references and a full description of your requirements. Professional artists often use computer software to create or finish designs so they can achieve a much cleaner line finish than is possible by hand, and you can wind up with a very stylized and professional design.

Tattoo color

The color choices you make for your design can drastically change the look of your tattoo. Clean black line work can allow more detail than color. Choose a simple color palette for smaller designs and make sure the colors look good together, as well as with your skin tone and even your favorite clothes. A broader color palette can be used for larger designs, and your tattoo style may also lend itself to certain color combinations. Try out your design with a few different variations, or with combinations you wouldn't normally consider, to see what works best.

Color in your tattoo design can add interest by being unexpected–such as a green rose or a purple building–or add contrast, for example, soft pastel watercolors used behind or throughout a dark heavy scene. Your color choice can add to the layers of meaning in your design; your favorite color, the color of your sports team or national flag, your birthstone color, even the colors of your favorite flower are all options.

Color is usually added in one of three ways: a block of uniform color within a form or shape; a color that blends into another, or the same tones of color used as shading to add depth. The way you add your color, and the results you can achieve, depends on how you create your design; hand painting or coloring can have a sketchy look but are ideal for watercolor effects, whereas computer programs will allow you to easily add uniform color or create tonal and shading effects.

This floral tattoo looks delicate in black and white and the fine line work shows up particularly well.

These soft colors make for a pretty, feminine tattoo.

Stronger colors transform this into a much bolder tattoo.

Draw it

Drawing your tattoo by hand is perhaps the simplest method to create or customize your design and requires only basic equipment. You don't need to follow every step in order—you could start by hand drawing and then scan and continue your design using computer software (see p47), or sketch your composition roughly and draw by hand using tattoo pens (see p60), or draw your design elements in the rough size and style you'd like them and then pass on to a professional artist. Hand drawing is a mainstay of tattoo design, so let's get started!

What you'll need

- lead pencils
- black felt-tip pen
- ruler
- eraser

Perhaps:

- tracing paper
- colored pencils
- markers
- watercolors

Handy to have:

- light box

(see p48 for how to make your own)

Tip

See the section on tracing (on p44) for tips on tracing elements of your design.

How to hand draw or trace your tattoo design

1. Choose a size to draw

It can be helpful to do a sketch in the size you intend to print your finished tattoo so you can check that the detail is easily seen. Mark your tattoo size on your paper as a guide to draw in. If you are planning to wrap your tattoo around a body part, try holding paper up to that body part and using a pencil to outline where you'd like it to go in order to create a template shape to draw in.

2. Sketch the main outline

Use a pencil sketch in the main element or subject of your design, working from a reference image or photo, flash or vintage design, or photo of a tattoo. Draw your design freehand, or use tracing paper and/or a light box to trace the components of your design.

3. Customize

Add or remove elements as needed to create the first draft, customizing your design and checking your composition.

4. Finish the outline

When you're happy with your draft composition and lines, start to tidy up your design by erasing excess lines and darkening the outline. Then trace the outline using a black felt-tip pen, wait for the ink to dry, and erase all pencil marks. If you have a complex design or are not confident coloring, it's a good idea to scan or trace your design at this stage so you can go back a step if you need to.

5. Adding color

If you're using color in your design, you can either hand color using colored pencils, felt-tip pens, or watercolors, or add color using a design program.

You can scan your finished ready-to-print design into a computer, or photocopy directly onto tattoo paper. If you scan your design you can use design software to make slight adjustments, retrace for a clean line, or add color.

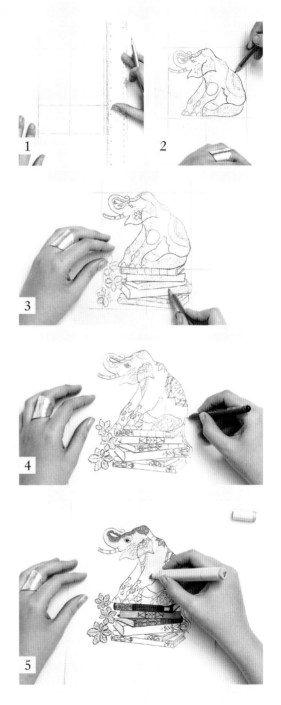

How to use grids

You can use a ruler to draw a simple grid line in pencil as a guide, or onto a clear plastic sheet such as vellum or an Overhead Transparency (OHT) to place over one of the images in this book.

1. To copy an image and maintain the dimensions, draw or place a grid over the original, and copy into a grid of the same size on paper, keeping the same lines and detail in each square.

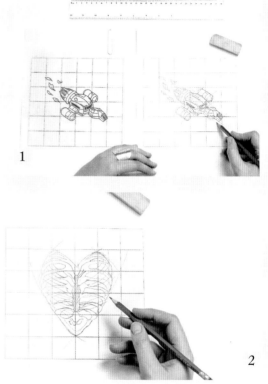

1

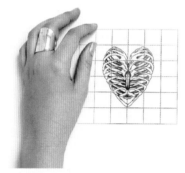

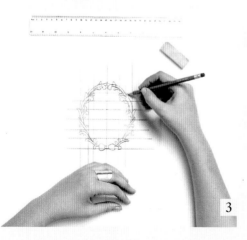

3

2. Some elements may need resizing before adding to your composition, or you might like to resize the entire design. Use a grid to enlarge or decrease your design by drawing or placing one over the reference image you're using. Then on paper, draw a grid with the same number of squares, but in the size you'd like, and draw the design in the new grid keeping the same lines and detail in each square but scaling them up or down as necessary.

3. Check the symmetry of your design using a grid—useful for geometric designs, a portrait, or one depicting an animal or plant with natural symmetry.

2

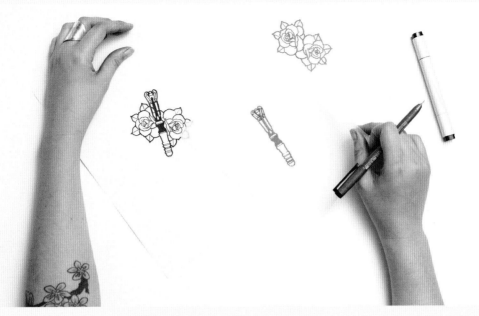

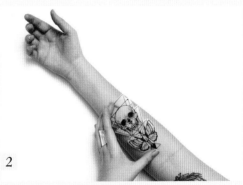

How to use tracing paper

You can use tracing paper or greaseproof baking paper to help with designing and sizing.

1. To test combining elements, or different combinations, trace different parts or elements of your design on different sheets of tracing paper, lay them over the top of each other, and hold up to the light to see how they'll look together.

2. Test sizing by holding your design against the body part on which you'd like to wear it.

3. Copy your design before adding color or before a step you're not sure about, so you can go back a step easily and retrace the original.

Megan's family tattoo design

"I want a large tattoo design for my arm, representing my mother in some way and the concept of family, which is very important to me. I like American Traditional styles with thick line work and a fair bit of detail. I'd like my tattoo to communicate a lot of meaning and symbolize how I feel about my family."

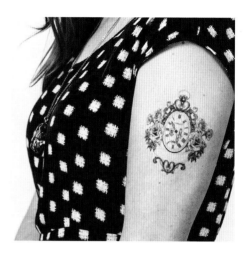

In this design, Megan's mother is symbolized by the clock showing the date and time of her birth, and this is also signifying the fleeting passage of time with loved ones. Roses signifying love are featured on each side of the banner along with blue forget-me-nots. The banner will hold the text of Megan's life motto about loved ones being the most important way to spend our time.

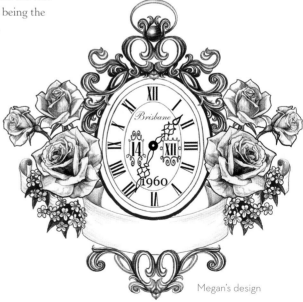

Megan's design

David's tribute tattoo design

"I want a tattoo that pays tribute to my favorite women; my wife and my grandmother, both strong women who have inspired me in so many ways and made me a better person. I'd like it in a medium-large size in bright colors to be worn on my forearm."

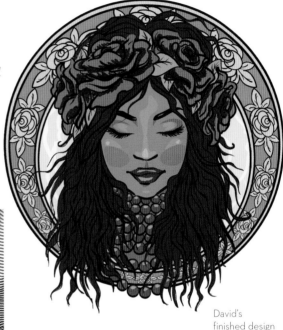

David's finished design

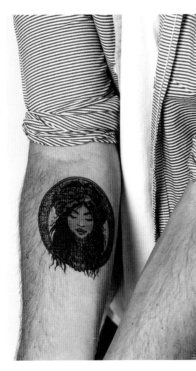

In this design, David's wife is drawn in an illustrative style and framed in a beautiful circle composition using a simple color palette. The thick lines and color contrast make the tattoo visible, especially on David's mid-toned skin. Roses—which are both his wife's favorite flowers and also representative of love and beauty—are incorporated. In the design the woman is wearing pink pearls to commemorate David's grandmother, Pearl.

Amanda's crown tattoo design

"I would love a tattoo incorporating a crown to signify being queen of my life. I'd like it for my wrist in a small–medium size. It would be nice to incorporate a butterfly as well—not too girly, though—because I love what they symbolize, and some leaves or nature in some form. I'd like it to be black line work only and look like a vintage illustration style."

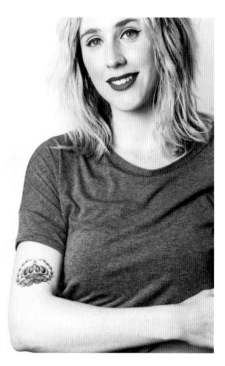

The crown and moth were both sourced from vintage illustrations and put together with an ivy wreath, which Amanda liked because it brought additional meanings of peace and victory to her tattoo. The finished detail was most effective in a medium size so Amanda wore it on her forearm instead of her wrist.

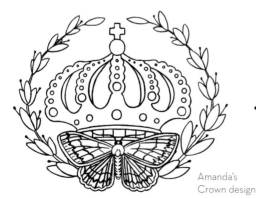

Amanda's
Crown design

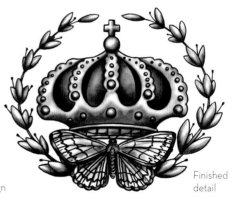

Finished
detail

Pippa's duck and fox tattoo design

"I'd like a tattoo featuring my two favorite animals; a duck and a fox. I love the fox's intelligence and sleek beauty, and the duck's simplicity and the way they both remind me of home. Together they make me think of the duality of people; how our two sides—the hunter and the hunted—balance us out."

This design illustrates the fox and duck in vivid watercolor, with fine dotwork patterns within the bodies that both provide visual detail and break up the solid areas of ink so the tattoo will bend easily on the skin. The plants add additional meaning, with dandelions representing our wishes and dreams, and framing the design beautifully. The small details need a medium–large tattoo to be seen; in a large size Pippa could wear this tattoo on her arm, upper back, thigh, or calf.

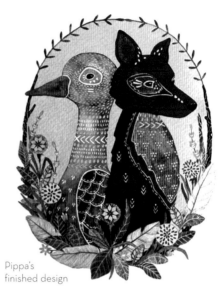

Pippa's finished design

Tracing your design by hand

You can combine a traced design with hand drawn elements to create your own personalized tattoo. This technique can be used to combine simple elements or you can trace a complete design directly onto tattoo paper and wear it right away.

What you'll need

- tracing paper
- pencil and eraser
- pen, colors if using
- paperclips

Handy to have

- light box

(see p48 for how to make your own)

Tip

After step 4 you can copy your design straight onto skin using tattoo pens—see p60.

How to trace your design in pencil

1. Place your tracing paper over the design you'd like to trace and fasten it with paper clips so it doesn't move. Using a pencil, trace the lines of your design onto the tracing paper. Use a light box (see p48) or window if the lines are tricky to see.

2. Unclip your tracing paper and clip to your other reference images or designs to trace other elements and add them to your design. If an element needs resizing before you can trace it, use a photocopier, resize it on a computer and print, or see the tips on p38 to resize using a grid.

3. Once you're happy with your pencil tracing, erase extra marks. If you're tracing directly onto tattoo transfer paper, skip step 4 and go straight to "How to trace your finished design onto tattoo transfer paper" on the next page.

4. If you are scanning or photocopying your design, trace over your lines with a black marker and erase the pencil lines. Photocopy or trace onto regular paper to add color with markers, pencils, or paints.

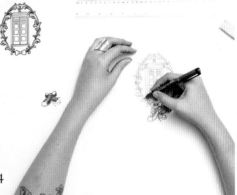

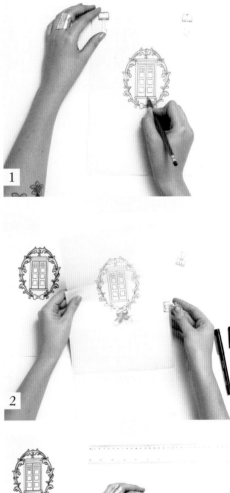

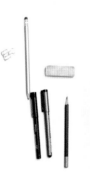

How to trace your finished design onto tattoo transfer paper

1. Lay your pencil drawing image side down onto the "print" side of your tattoo transfer paper. This is usually the side with a slight sheen to it, but check the instructions that came with your paper.

2. Fasten the tracing paper with paper clips so it doesn't move, and using the side of your hand gently rub the back of the tracing paper so the pencil outline transfers to the transfer paper.

3. Remove the tracing paper. If the lines are too faint, try retracing the lines with a soft pencil and rubbing again. Your image will appear back-to-front; this is correct! It will be reversed again and appear the right way around when you apply it as a temporary tattoo.

4. Use pen to outline your design and then erase your pencil marks. Add color with markers, pencils, or paints. Follow the steps on p55 to add the adhesive to your tattoo transfer paper and apply!

> ### Tip
> Look out for the "color me in" icons on our templates.

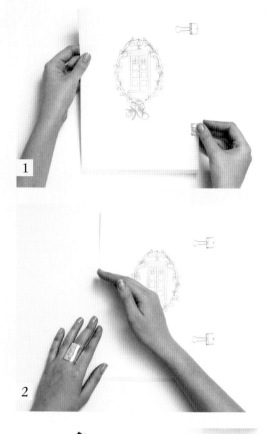

1

2

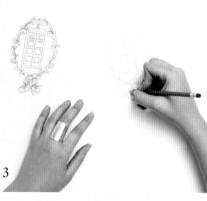

3

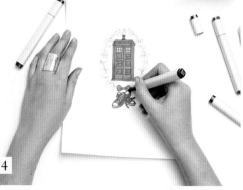

4

Computer design

There are many design programs you can use to create a tattoo design, or finish a hand-drawn design that has been scanned and uploaded. With most design software you can scan and outline images, build using shapes, import pictures and combine elements from different pictures, play with sizes, color using block color or shading, and tidy up lines and sketch marks. Software allows you to play with digital manipulation—such as changing the depth of field and angles—or layering images for unique results. Creating or finishing your design using software makes it easy to save your steps, your final image, and reverse your image for printing.

Computer programs vary from simple free programs to more powerful professional software used by designers, so there is too much variety to give one set of instructions. If you are familiar with a program already, you could create your design right away, or see the Resources section at the end of this book for links to download simple software with tutorials.

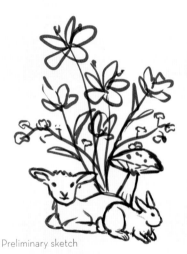

Preliminary sketch

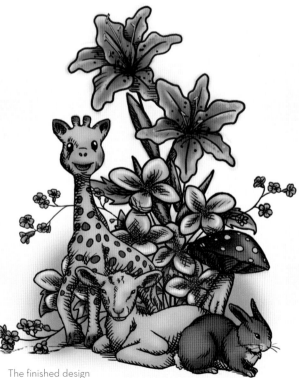

Refined sketch

The finished design

A light box is very handy to help trace complex details or fine lines that are difficult to see through tracing paper. You'll need to have the image you're copying from on a single page, so if it's in a book or magazine, photocopy that page before you continue.

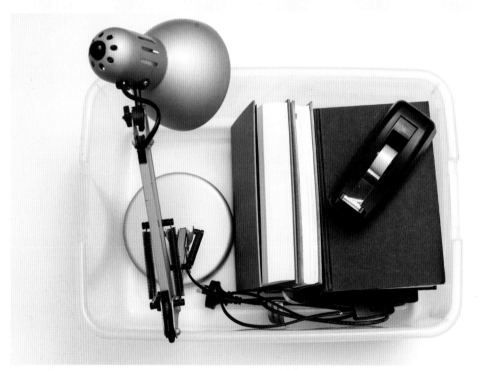

What you'll need

- semi-transparent or transparent storage tub
- books or similar
- desk lamp
- sticky tape

How to make a light box

1. Position a desk lamp in between two piles of books.

2. Place the transparent box upside down and over the lamp, resting on the books.

3. Place your image and tracing paper on top and use tape to fasten them to the box. Trace using a pencil.

Tip

You can also tape your design and tracing paper to a bright window and trace.

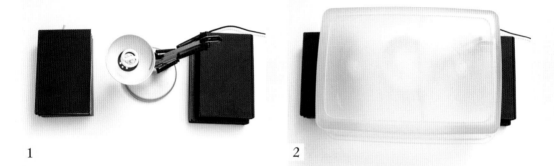

1

2

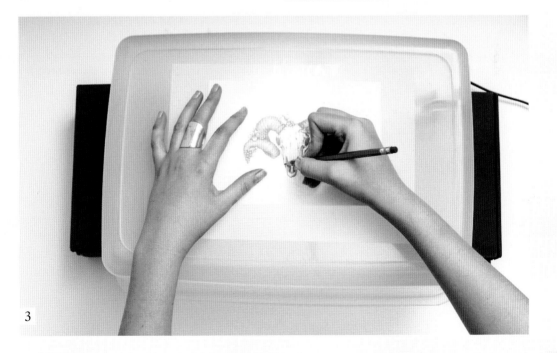

3

Print it

So your design is finished! There are a number of ways to now convert it into a ready-to-wear temporary tattoo. If you have hand drawn your design you can trace directly onto the tattoo paper (see p46), photocopy onto the tattoo paper, or use a scanner to upload your image and print from a computer; if your design is on a computer you can print directly onto the tattoo paper. We'll cover these techniques over the following pages.

Choosing tattoo transfer paper

To ensure the best possible result it's important to use high quality tattoo transfer paper for your temporary tattoos. Tattoo transfer paper can be found in craft stores and online; use a reputable brand and read the instructions carefully. Tattoo paper is available for both inkjet and laser printers, which also effects the end quality.

(See the Resources section at the back of this book for websites to purchase quality tattoo paper.)

Inkjet vs laser printer

Tattoo paper is available for both inkjet and laser (toner) printers–be sure to get the correct paper for your printer. Inkjet paper and printing gives a sticker-like finish, whereas laser paper and printing has a more flexible and long-lasting tattoo effect. If you have a choice of printers, the low-end printers with a lower dpi (the concentration of the ink on the page) give a better result, as the layer of ink will be thinner, which will result in the tattoo being thinner and more flexible on the skin.

Custom print tattoos

You can also have your tattoo design custom printed by a business specializing in printing temporary tattoos. Digital printing is the best option for short-runs (usually from 1–999 prints) and most commonly involves a laser printer. Offset printing is usually used by professionals as it uses large printing presses and because of the greater set-up costs usually requires a minimum run of 1,000 tattoos. You could consider this is you want to become a professional temporary tattoo designer.

Safety

Please follow the safety guidelines (see page 2) on how to use tattoo transfer paper safely.

Note

See the Resources section at the back of this book for websites to order custom tattoo prints.

How to print your tattoo

Printing from a computer

1. In your design program, set the page size to A4 or Letter, the size of the tattoo paper.

If you are not using a design program, open a publishing or word processing program that supports images and set the page size to A4 or Letter. Import your design using the "insert picture" or similar function.

2. Measure the body part where you'd like to wear your tattoo to get the exact size, and alter the size of your design accordingly.

3. You'll need to "flip" the design so it is the correct way around when you apply it to your skin. You can do this using a "flip horizontal" or "reverse" tool in your software.

4. Repeat steps 2 and 3 for any other designs you'd like to add to the page. Try to fit them together on the page like a jigsaw puzzle.

5. Place a sheet of tattoo paper in your printer so that it will print on the non-marked side.

6. Print out and wait a few minutes for the ink to dry—you should be able to touch it without smudging.

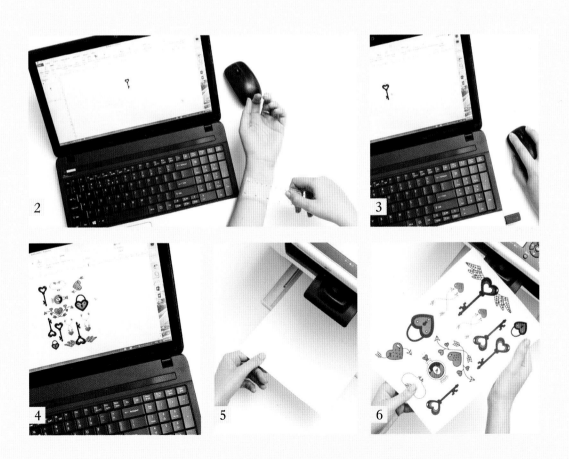

Photocopying

1. You'll need to "flip" the design if you want it to appear the same way around on skin as the original. You can do this by photocopying your design onto an overhead transparency (OHT) or plastic vellum. Check that the vellum or OHT is safe to use with your printer. This is especially important for designs with text. If it doesn't matter that your design is reversed, you can skip this step.

2. Measure the body part you'd like to wear your design on to get the exact size for your design.

3. Use your photocopier's "enlarge" or "decrease" functions until your design is the correct size. Try to photocopy from the image on the vellum only (not from other copies) to retain the image quality.

4. Repeat steps 1 and 2 for any other designs you'd like to add to the page. When you have flipped and sized your images accordingly, cut them out and arrange them to fit the page.

5. Photocopy your designs onto the tattoo paper on the correct side (check the manufacturer's instructions) and wait a few minutes for the ink to dry—you should be able to touch it without smudging.

Tip

It's a good idea to print or copy a test page on regular paper first to check the size of your design (cut it out and hold it to your skin image side down to check) and ensure it is reversed (you can hold the paper up to the light and facing away from you to see the image the correct way around).

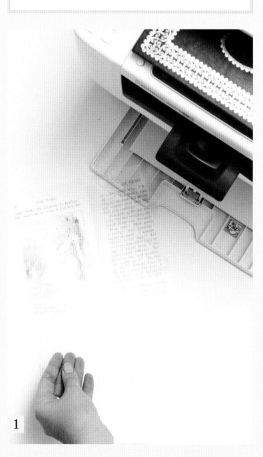

1

Tip

Every time you photocopy a design you lose some image quality so try to limit the number of copies you make—you should be able to do it with three copies only; one to flip, one to size, and one final copy.

Tip

If you're not sure which side your printer or photocopier prints on, mark a plain piece of paper with an "x" and place in the machine with the "x" facing up. Print or copy something and note if it has copied the side containing the "x" or the reverse side.

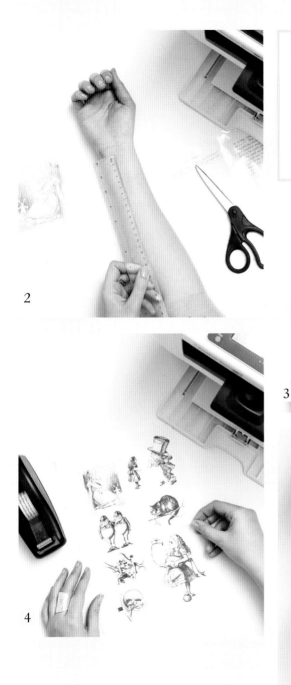

2

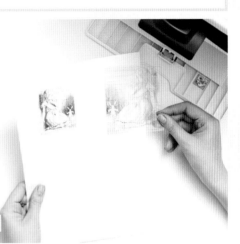

3

4

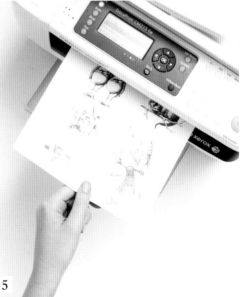

5

Applying the adhesive sheet & cutting out

Once your design is on the tattoo transfer paper, check that it is reversed (it will reverse again and appear the correct way around when it's applied to your skin). Applying the adhesive sheet can be tricky so take your time to line up the plastic film. If a bubble appears you can usually smooth it out using a ruler with firm strokes. However, if a crease appears you may need to remove the film and try again as it means the adhesive is folded and the crease will continue down your page.

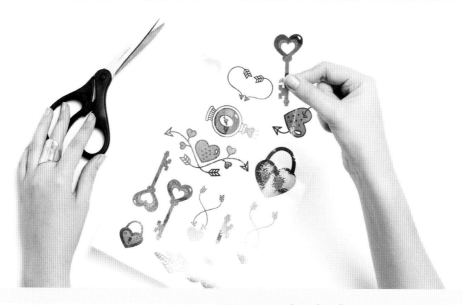

What you'll need

• your tattoo transfer paper and adhesive sheet

• a flat surface

• a plastic ruler

• scissors

ABOVE: Once the adhesive sheet has been applied you can start to cut out your designs.

How to apply the adhesive sheet

1. Carefully peel the backing paper off the adhesive sheet on one corner, taking care not to touch the sticky adhesive.

2. Fold the backing paper a little way down from the top and line up the plastic sheet with your page, adhesive side down.

3. Press the adhesive onto the paper working from the middle.

4. Carefully smooth the adhesive over the paper, being careful to avoid creases.

5. Turn the page and, using a ruler, smooth out the adhesive.

6. With your other hand, pull the paper slowly as you slide up the page with the ruler.

7. Continue sliding the ruler firmly up the page until the adhesive completely covers the paper.

8. Go over the sheet with the ruler, using even pressure to smooth out any bubbles under the film.

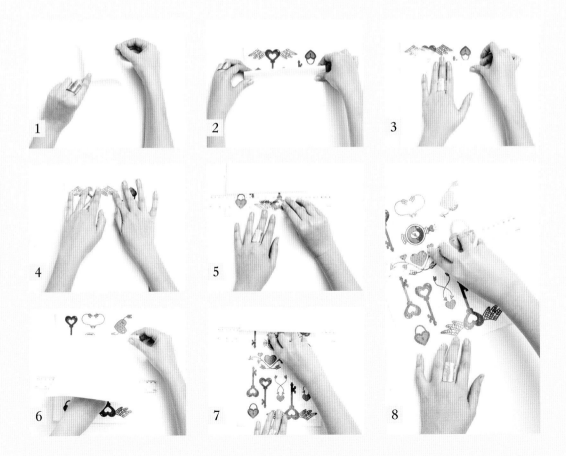

Ink it

If you're using tattoo transfer paper, the steps below will show you how to apply your tattoo to your skin, and we'll then go on to talk about how to make it last. These are general steps that are applicable to most tattoo transfer papers, but always check the instructions provided with your paper.

Before you start

Use soap and water to clean the area of skin where you'd like to wear your tattoo and dry thoroughly with a towel. Any products on your skin, natural oils, or dirt will interfere with the adhesive bonding with your skin and therefore decrease the life of your tattoo.

What you'll need

• your cut out tattoo

• bowl of water

• facecloth or sponge

1. Carefully peel the plastic film off your tattoo design, gently bending the paper and using your fingernail to separate it from the paper. Discard the plastic film.

2. Press your tattoo paper onto your skin, image side down, checking that it is in the correct position and orientation. If you're applying on a limb, try to hang your limb as naturally as possible. If you hold your limb strangely when applying, the skin stretches in an unusual way and as soon as you return to your normal position the tattoo may stretch or crack.

3. Using a wet sponge or facecloth, wet the back of the paper and hold for 20 seconds. It's important not to rush this step as the paper needs to be thoroughly soaked to release the design. If you are impatient and remove the backing paper too soon you may have white flecks remaining, or part of your design could come away with it.

4. After 20 seconds remove the wet cloth and the backing paper should slide off your skin easily. Use extra water to rinse your design and carefully pat dry with a towel.

5. You're done! You can take extra steps to remove the sheen from your tattoo, or leave it as is.

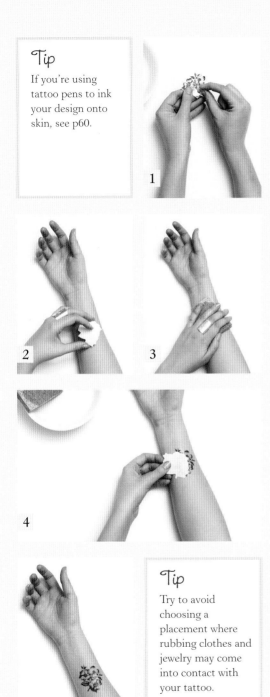

Tip
If you're using tattoo pens to ink your design onto skin, see p60.

1

2

3

4

Tip
Try to avoid choosing a placement where rubbing clothes and jewelry may come into contact with your tattoo.

5

Removing the shine

Most temporary tattoos created using transfer paper will have a slight sheen to them as a result of the ink used. The amount of shine depends on the quality of the paper and the method of printing. Most of the shininess should fade after a few hours or a day or two, but you can also take steps to remove some of the shine right away.

Remove shine with DIY

After applying your tattoo using the previous steps and drying thoroughly, place a tiny spot of non-alcohol-based moisturizing cream on the tip of your finger and rub it between your finger and thumb. Brush your finger over your design carefully to cover it in a very thin, even layer. Using a large makeup brush, dust translucent face powder over your tattoo. This method will remove most of the shine, but care must be taken to not dissolve the adhesive or lift the edges of the design.

Shine remover products

Specialized products are available to remove shine from temporary tattoos, used in the movie and television industry to create realistic effects. They usually work by adding a tiny layer over the tattoo, which also increases the longevity of your design by protecting it from moisture and making it more flexible on the skin.

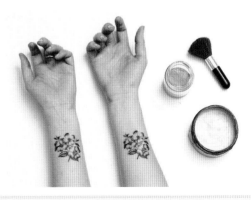

How long will it last?

How long your tattoo will last depends on many factors. The transfer paper quality, print method, tattoo size, and placement all affect your tattoo longevity, as does your skin type, activity level, and even the weather. Check the details on the packaging of your tattoo transfer paper, and see the tips below to make it last as long as possible.

1. Avoid applying lotions or creams near your tattoo including suntan lotion or sunscreen, moisturizing cream, and perfume. Any oil-based or alcohol-based lotions can dissolve the adhesive and leave your tattoo sticky or remove parts of it entirely.

2. After swimming or showering, pat dry your tattoo. Rubbing your tattoo can rub it off, especially around the edges.

3. Try to avoid holding your tattoo under hot running water for any length of time, as hot water can melt the adhesive and make your tattoo sticky or cause it to come off.

Tip

If you've just removed a tattoo, give your skin a few days to breathe before applying another.

Tip

If you are very active, sweat can cause sweat bubbles under large designs. Use a clean pin to carefully pierce the film of your tattoo and smooth out the bubbles.

Removing your tattoo

Your tattoo will naturally wear off over time, but if you'd like to remove it fully or if it becomes sticky or dirty, try one of the following methods. You can also check the manufacturer's instructions on your tattoo transfer paper packet.

1. **Sticky tape**
 a. Place strips of sticky tape over your tattoo and rub firmly so it adheres to the design.
 b. Remove quickly, stretching your skin with one hand (if it's free) and keeping the other close to the skin. Always remove in the direction of your hair growth.

2. **Alcohol wipes**
 a. Hold an alcohol wipe over your design for a few seconds.
 b. Rub to remove. Repeat with more alcohol wipes until fully removed.

3. **Hot water**
 a. Hold your design under running hot water for several minutes (this is easy to do in the shower).
 b. Rub your design from the edge inward to remove.

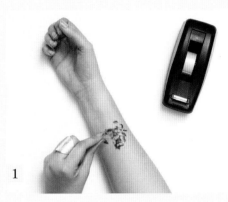

1

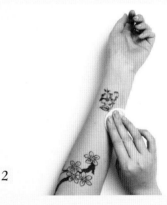

2

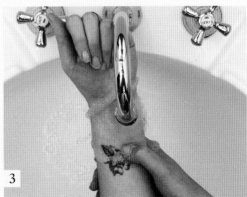

3

Tip

Sticky tape isn't as effective if you are removing an old tattoo or have applied translucent powder to dull the shine.

Using tattoo pens

Skin-safe tattoo pens allow you to draw your tattoo design directly onto skin. You can draw entirely freehand, or use a grid to copy a design you've already created. Some brands also come with correction pens to fix mistakes as you go, and ready-made stencils that you can use alone or combine with your own designs. Always purchase high quality pens and if you're buying online or internationally, check the safety standards of the country of origin.

Drawing your design freehand

1. Start with clean and dry skin where you'd like to draw your tattoo. If you're drawing on a friend, make sure they're comfortable and won't need to move for a while.

2. Draw your design using your tattoo pens—there are many colors available. You can be led by a style guide in this book, pick up some inspiration from the Gallery in Chapter 3, or create something completely new.

3. Fix mistakes as you go or remove entirely using alcohol wipes, correction pen, or by following the manufacturer's instructions.

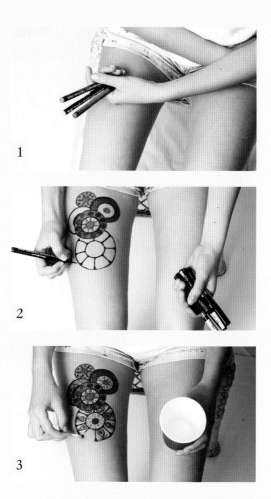

1

2

3

Copying

1. Draw a grid over your design using squares of a set size and mark dots of outlaying lines on your skin using a ruler.

2. Copy the design by drawing lines in between the dots, using your design as a constant reference as you draw.

3. Add color to your design last.

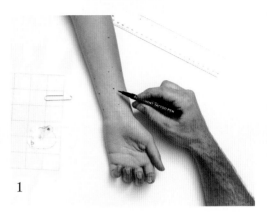

1

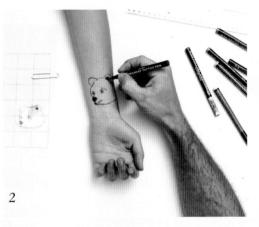

2

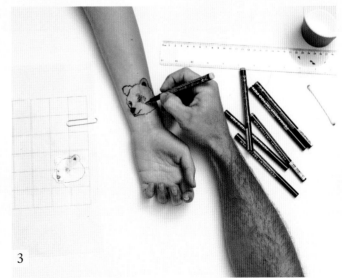

3

Tip

Read the instructions on your tattoo pen packet for more information and techniques, removal recommendations, and care instructions.

Tip

You can use tattoo pens in conjunction with tattoo transfer papers to add detail or embellishments, or to customize a banner or design.

3
Inspirational Gallery

This inspirational gallery is full of tattoo designs
and ideas by contemporary artists, ready to be traced
directly for your temporary tattoo, used to mix and
match your favorite elements for your own design,
or simply to inspire. Here we also cover common
meanings and interpretations so you can get a sense
of how you can communicate your tattoo meaning
through your design and continue your research to
find new meanings and symbolism.

Note

These designs are for personal use only, not
for commercial use or resale. You can trace,
copy, or download some of these illustrations
to use either for your own tattoos or for an
event with friends and family–but please
don't create tattoos to sell, or distribute
these images in any other way. Only tattoos
that feature a QR code or web link are
available for you to download.

Customizing your tattoo

Unless you draw your entire design from scratch, chances are you'll be customizing an existing image to incorporate it into your tattoo, or at least using reference images to create your design. You can customize in many ways to make an image, or collection of images, uniquely yours. You can add to a design by introducing new elements such as a flower, banner, text, or geometrical patterns or lines. You can alter a design by creating the same combination of images in a completely different style, or by keeping the original style and changing the colors used, or by simply changing the composition or arrangement. You can subtract images, line work, or color from a design and replace them with something else. You can combine elements of one or more designs into a new composition. Or you can do all or any combination of the above to fine-tune your design until it's just how you want it.

Look through your reference images and design checklist to see if you have a base design to work from—one depicting the main subject of your tattoo, or one with the most number of elements you'd like to keep—and then list the changes you'd like to make to incorporate your other ideas or meanings, to fit your body part, or to adapt to your style.

If you are combining elements, be sure to keep the style consistent, i.e. the line thickness and color palette, so the elements are tied together and form one new cohesive design. Try drawing different elements of your design on tracing paper so you can see how they work together, and experiment with various combinations. Customizing your tattoo is how you make it exceptional!

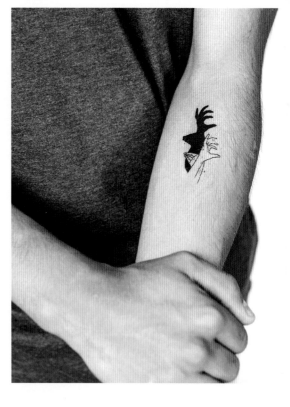

Tip

Use the QR code found next to some designs to open the image on your computer and print right away!

Animals

Animals are prevalent in folklore and mythologies in cultures around the world, and represent different virtues and symbolic significance in different places. In addition to broader cultural or spiritual meanings, animals can carry personal meanings—for example, beloved family pets or characters from a favorite book; can signify a place or time such as a native animal or extinct animal; or can be a nod to heritage and beliefs if using an animal from a myth or historic legend, or an animal totem; or speak of personal attributes through zodiac, totem, or spirit animals. You can also imply an animal in a design by depicting just part of it, such as a claw, tooth, or feather.

Meanings

Lion: Strength, courage, majesty, bravery

Bear: Power, strength, maternal love

Horse: Companionship, power, grace, beauty, freedom

Wolf: Leadership, strong mythology in Europe and North America

Fish: Fertility, abundance, wisdom. The Koi represents strength and courage in Japan

Fox: Cunning, intelligent, playful, strategic

Turtles: Sure and steady, self-protective, patience and stability

Elephant: Wisdom, memory, strength

Bee: Work, community

Mouse: Timidity, hard work

Dragon: Wisdom, strength

Phoenix: Rebirth, strength

Unicorn: Beauty, imagination, magic

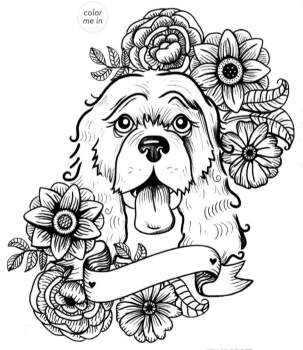

color me in

Pet tribute

This pet portrait can be personalized with text on the banner, or replace the dog with a drawing of your own pet!

bit.do/770601

Wolf in sheep's clothing

Pencil sketch illustration of a wolf in sheep's clothing.

bit.do/770602

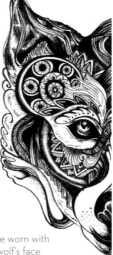

Wolf

This design could be worn with both halves of the wolf's face together, or split between two arms, legs, or worn half on one person and half on another.

bit.do/770603

Koi

This koi would look great on your arm or thigh.

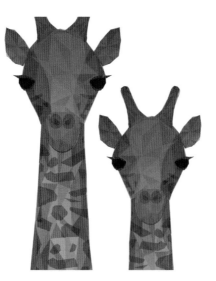

Giraffes

These two giraffes could be a parent and child, siblings, or best friends!

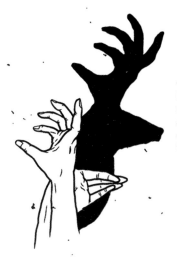

Silhouette deer

Representing an animal in an unusual way, a silhouette like this could also be used for other animals.

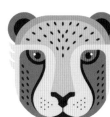

Woodland deer

Pretty woodland deer with flowers in the antlers. You could trace this deer and add your favorite flowers.

bit.do/770604

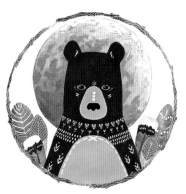

Geometric animals

Choose your favorite or wear them together as a jungle tattoo sleeve.

Bear and moon

This illustration has fine detail more easily seen when worn as a large tattoo.

bit.do/770605

Paw prints

Cute paw print designs for an animal or pet lover.

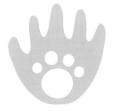

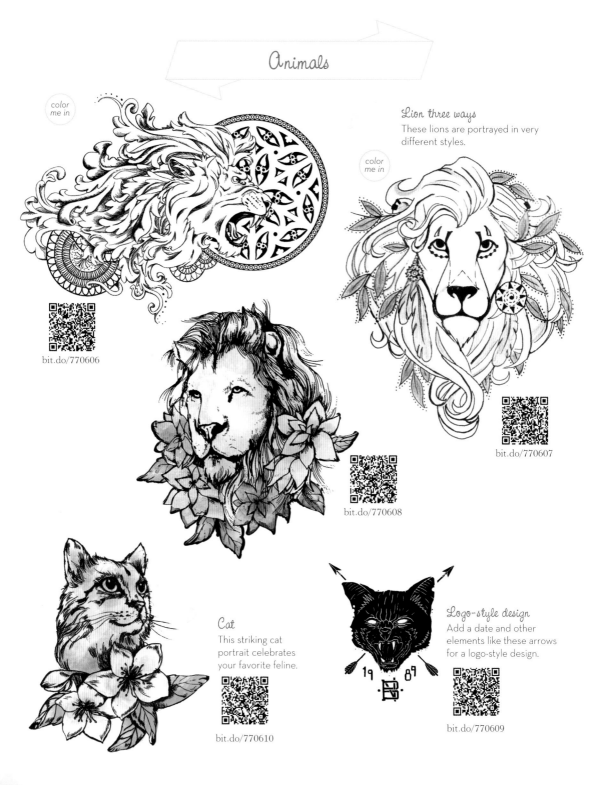

Animals

color me in

Lion three ways
These lions are portrayed in very different styles.

color me in

bit.do/770606

bit.do/770607

bit.do/770608

Cat
This striking cat portrait celebrates your favorite feline.

Logo-style design
Add a date and other elements like these arrows for a logo-style design.

19 89

bit.do/770610

bit.do/770609

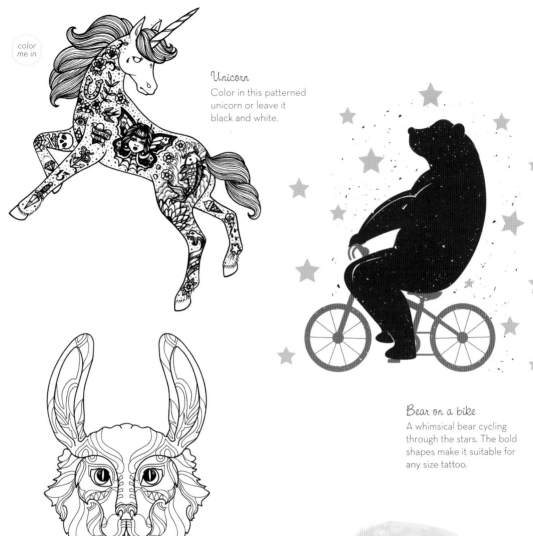

color me in

Unicorn
Color in this patterned unicorn or leave it black and white.

Bear on a bike
A whimsical bear cycling through the stars. The bold shapes make it suitable for any size tattoo.

Bear in socks
Use an animal from your favorite picture book, like this bear in socks.

bit.do/770611

Rabbit head doodle
Wear this rabbit head in black and white or color it in with your favorite colors.

Birds

Bird tattoos usually represent freedom and can be portrayed in many different ways. They are about spreading your wings and flying through life despite hardships, and also carry additional meanings depending on different cultures, countries, and communities as well as the species of bird. They are commonly worn on the upper back or along the chest bone, or on the arm or wrist or as part of a larger composition.

If you're interested in a bird tattoo and want to dig deeper, research your favorites to find out more about birds in myths and legends, history, cultural celebrations, and fairy tales. You can personalize a bird design by choosing a bird that represents something meaningful to you, then perhaps incorporate elements such as flowers, text, or a banner to add layers of meaning.

Meanings

Swallow: Good luck and protection

Hummingbird: Simplicity and femininity

Eagle: Pride, strength, and grace

Dove: Peace and humanity

Sparrow: Journey, home, and true love

Geese: Long marriage

Owl: Wisdom, intelligence

Crow: Darkness, intelligence, death

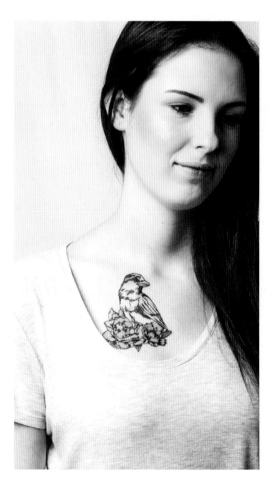

Sparrow
Soft shading and lines give this sparrow a soft, feminine look.

bit.do/770612

Lovebirds
Cute lovebird budgies on a blossom branch.

Swallows
The same outline but different infills make these swallows a contemporary matching pair.

color me in

Patterned bird
This bird is made up of different patterns and silhouettes—try outlining an animal shape and making your own pattern infill.

Illustrative sparrow
This adorable illustrative sparrow could perch on an arm or shoulder.

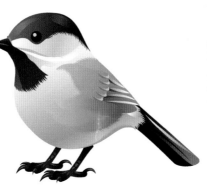

Birds

Owl

These mirrored designs look great on opposite arms, feet, or shoulders.

bit.do/770613

color me in

Feathers

These gorgeous feathers contain intricate patterns.

Owl portrait

This owl sketch could be combined with color elements to great effect.

bit.do/770614

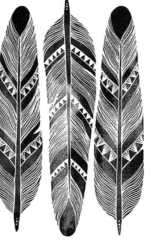

bit.do/770615

Bird's nest

A bird's nest can convey safety and security in the family.

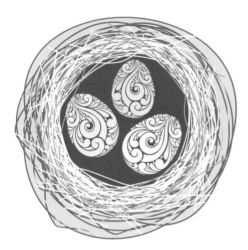

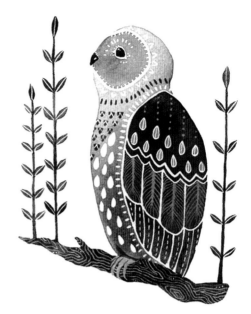

Watercolor owl

An owl in striking watercolor. Notice the absence of color in the markings of the chest, which means the area will be skin toned when worn.

bit.do/770616

Bright bird

This bold, bright bird could be worn in any size or combined with similar styles, like the flowers on page 77.

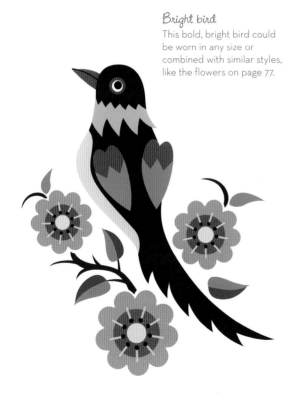

Rhino birdy

Here a sweet little bird has been incorporated into a larger design.

Butterflies & dragonflies

Butterfly, moth, and dragonfly tattoos are popular and meaningful, usually delicate, and suit many illustrative styles. They look great on the upper back, neck, wrists, and feet, and work well as part of a larger design. They all symbolize transformation as they grow from a caterpillar into a winged creature. In Greek culture a butterfly symbolizes the journey of a human soul from earth to heaven. According to Chinese culture a butterfly stands for joy, happiness, and prosperity and is a sign of good luck. You could personalize a butterfly, moth, or dragonfly design by altering the wing pattern and colors, and adding elements such as geometric lines, flowers, or animals.

Meanings

Butterflies: Freedom, beauty, grace, fragility, transformation, and great change or hardships

Moths: Metamorphosis, but also night and impermanence of life

Dragonfly: Good luck, strength, peace, harmony and purity, as well as transformation

Wings: Freedom, flight

Chrysalis: Change, transformation, unveiling

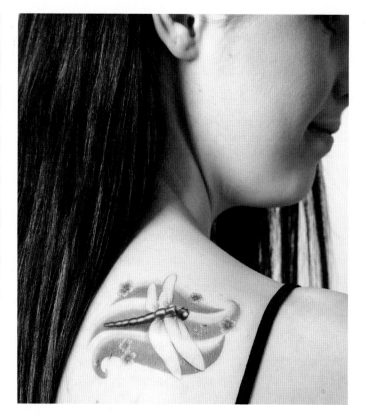

Dragonfly and cherry blossoms

This dragonfly design incorporates blue swirls to represent air and water, and is surrounded by tiny cherry blossoms.

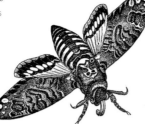

bit.do/770617

Vintage moth*

This vintage moth illustration has bold lines and is great to wear at any size.

Butterfly

This simple butterfly design can be left black and white or colored in to personalize.

color me in

Peonies and butterflies

A beautiful peony with circling butterflies.

bit.do/770619

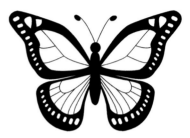

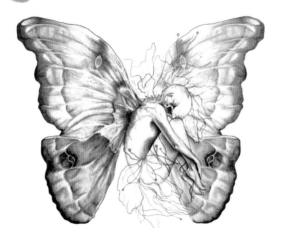

Butterfly fairy

A beautiful artwork in watercolor blues would be great in a large size to capture detail.

bit.do/770620

bit.do/770621

Dragonfly

This dragonfly illustration with bold lines is ideal for tracing.

Flowers

Flower tattoos are not only beautiful but are rich in symbolism and can carry a lot of personal meaning, making them ideal for your personalized tattoo. Flowers in general stand for love, fertility, and growth. Individual flowers have symbolism that can vary greatly between cultures and places, sometimes communicating completely different meanings. When contemplating flowers for your tattoo design you could consider using flowers from your wedding, or in memorial of a loved one, your birth flower, flowers from a particular place or a national or state flower to signify a place, or flowers in a meaningful color—all of these aspects can be combined with tattoo style and other elements to create a rich personal narrative, imbued with meaning and unique to you.

Meanings

Research your favorite flower for additional meanings in different cultures. You can also find flowers that represent each month, state and national flowers, and flowers in myth and legends.

Apple blossom: Heady love, peace, sensuality, and fertility

Rose: Love, beauty, passion, elegance, joy. Found in many old-school and vintage designs, very popular. Add thorns to signify loss, pain, or troubles in life

Sunflower: Energy, joy, good luck, accomplishing goals. Suits large designs as it contains small detail

Tulip: Opportunity, ambition, love, aspiration, rebirth. Different color combinations of tulips change the meaning.

Daffodil: Truth, honesty, faith. More recently signifying overcoming cancer

Violet: Modesty, shyness, a simple life

Iris: Wisdom, virtue

Magnolia: Beauty, dignity, renewal, love of both nature and life

Acacia: Love and friendship

Camellia: Graciousness, desire, perfection, longing for your beloved

Poppy: Sleep, death, and remembrance for those who have died in war

Daisy: Purity, innocence, love, and faith

Lotus: Enlightenment, inner beauty, peace, fortune. Symbolic in Hinduism and Buddhism

Cherry blossom: Prevalent in traditional Japanese tattoo art. See p80 for the definition.

Peony: The "King of Flowers" in Japan, symbolizes elegance and wealth.

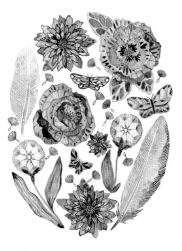

Watercolor poppies
This watercolor image could work well around a wrist or arm.

Tip
Suitable for all tattoo styles, floral designs are timeless and can work well anywhere on the body.

Floral gathering
This collection of soft watercolor flowers, butterflies, and feathers would make a great tattoo sleeve or could be cut into separate tattoos.

bit.do/770623

Floral diamond
This striking symmetrical floral design in bright colors can be printed in a large size for an instant tattoo sleeve or bracelet.

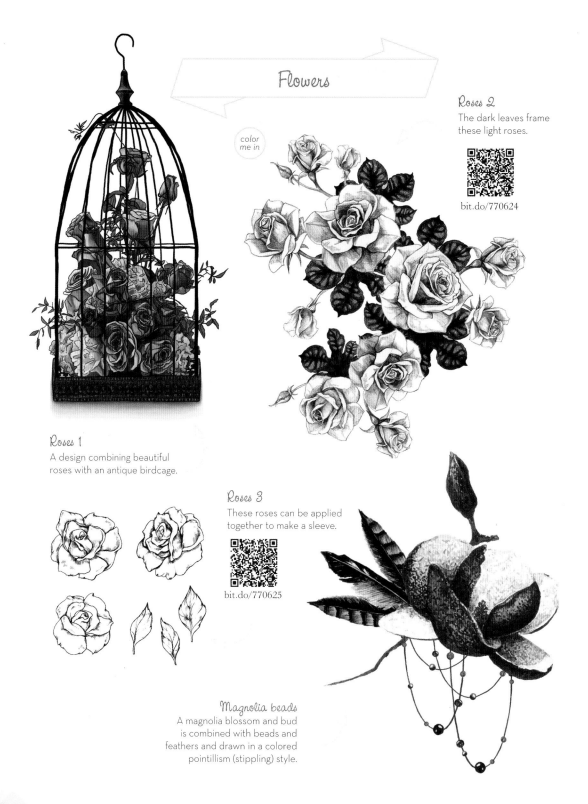

color me in

Roses 2
The dark leaves frame these light roses.

bit.do/770624

Roses 1
A design combining beautiful roses with an antique birdcage.

Roses 3
These roses can be applied together to make a sleeve.

bit.do/770625

Magnolia beads
A magnolia blossom and bud is combined with beads and feathers and drawn in a colored pointillism (stippling) style.

Lotus flower
Stylized lotus flower using beautiful patterns.

bit.do/770626

Bouquet
Bright and contemporary bouquet.

bit.do/770627

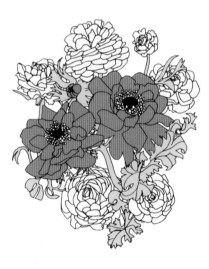

Anemones and ranunculus
Beautiful pastel anemones and ranunculus.

Simple flowers
Simple flowers, stems, and leaves—pick your favorite or wear them all at once.

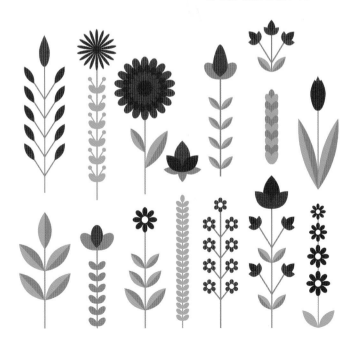

Plants & trees

Plants and trees can be used to great effect in your tattoo design.
They make wonderful backgrounds and can tie elements together, as well
as being great motifs in their own right. Trees and plants on the whole stand
for regeneration, renewal and growth, a love of nature, and the circle of life.
Trees often symbolize stability, family, and longetivity.

Meanings

Tree of life: A common motif across cultures
and in many mythologies, symbolizing the
source, and the interconnection, of all life

Tree roots: Stability, longevity, history

Olive leaf: Victory, peace, security

Poplar/aspen leaf: Courage and respect

Ivy: Endurance in love and friendship

Shamrock: Irish heritage, trinity, good luck

Cherry blossom: Transience, beauty, the
shortness of life, mortality

You can include plants and trees in your design
in more obscure ways then just picturing the plant
itself; a tree could be represented by the cross
section of a tree trunk, a distinctively shaped leaf
could represent the whole plant, and a plant's use
could be alluded to—for example, a tea-lover could
include a leaf from the camellia shrub, from which
tea is made.

Circle of life

This cross section of a tree trunk can represnt life, wisdom, or simply a love of trees.

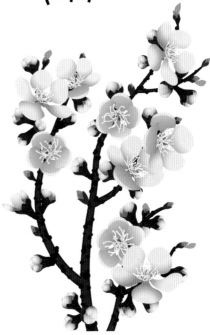

Heart plant

This simple design uses hearts for the plants and a collection of lines—the simplicity makes it perfect for small sizes worn on your wrist or ankle.

Mushroom and blossom

Mushrooms with blossoms in a pretty watercolor style.

bit.do/770628

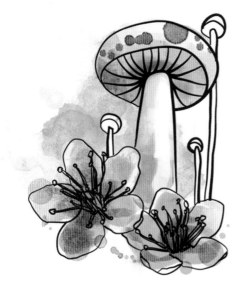

Cherry blossom

A branch from a cherry tree—check the meanings of the blossoms on page 76.

Plants & trees

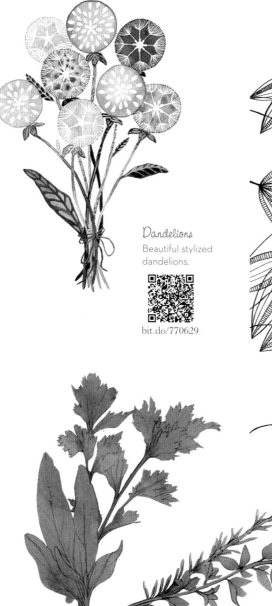

Leaves

These outlined leaves would look great in a larger piece or behind another element.

Dandelions

Beautiful stylized dandelions.

bit.do/770629

Herbs

Rosemary with thyme along with parsley and sage.

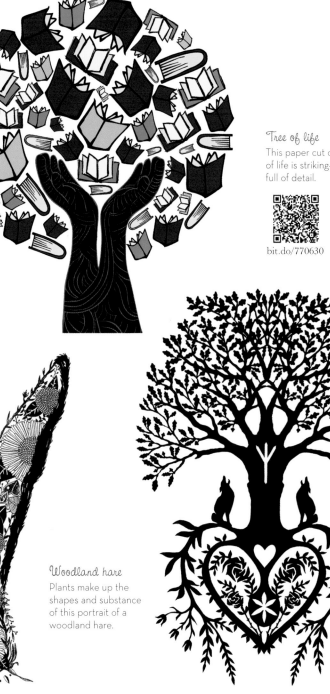

Book tree
This colorful tree is comprised of bright books.

Tree of life
This paper cut of a tree of life is striking—simple yet full of detail.

bit.do/770630

Woodland hare
Plants make up the shapes and substance of this portrait of a woodland hare.

Text

Text in tattoo design is a popular and simple way to communicate meaning and commemorate loved ones or significant dates. You can create a text-only design and use the style of lettering to communicate additional meaning, such as a handwritten message (in either your own or someone else's handwriting). You could choose a beautiful font to spell the name of someone special to you, or a strong font for a motto, or you can include your text in a design with a banner. Other text ideas include birth dates, quotes, messages, and song lyrics.

Meanings

Dates: Special life events, children's birth dates, weddings

Signatures: Commemorations

Lyric or motto: Personal meaning

Message: Birthday, Valentine's Day

Popular placements for text tattoos include strong lettering across the back, chest, or outer forearm; flowing script on ribs or shoulder blades; or bold, simple text for wrists or small designs.

Tip

See the Resources section at the back of the book for websites with free fonts to use in your design.

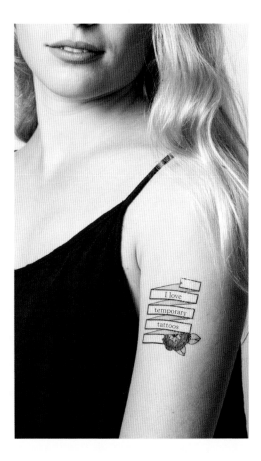

I love
temporary
tattoos

Rose banner
Add your own text to the banner of this gorgeous design, suitable for large sizes to show all the detail.

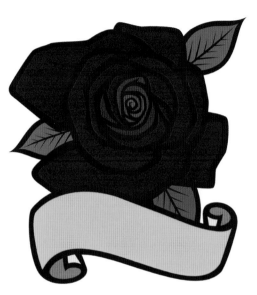

Poppy banner
Add your text to this banner with a classic poppy design.

bit.do/770631

Elvish text
This elvish-inspired text can spell out a name or message.

bit.do/770633

Inspirational phrase
Use your own handwriting or a handwritten-style font.

bit.do/770632

Text

bit.do/770634

Lightsaber banner
Add your own text to this *Star Wars*-inspired banner.

Heart label
Here, two vintage elements—an anatomical heart and a banner—have been combined in one design.

bit.do/770635

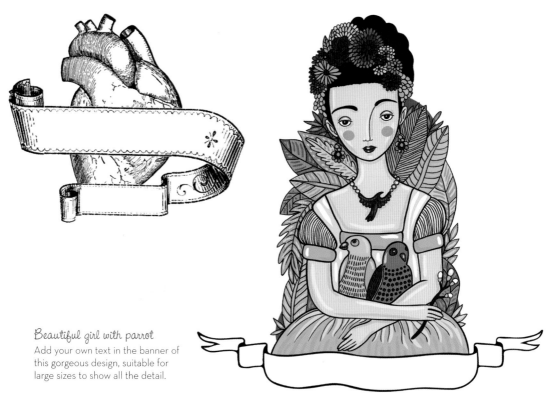

Beautiful girl with parrot
Add your own text in the banner of this gorgeous design, suitable for large sizes to show all the detail.

Banner-waving bear
You can incorporate banners in interesting ways into any illustration, like this bear waving a banner.

A name
A fun design using a name and bright colors.

color me in

bit.do/770636

Love tree
This love tree with banner has simple outlines and is ideal for tracing.

Passions & hobbies

What better way to revel in your passions than to create a design
to wear that references them in some way. There are so many possibilities
for a passion-themed design; list what you love to do and try
combining the subject with other elements that make you uniquely you;
like your birth flower, or hide your initials in the design.

Meanings

Equipment: Your love of a hobby or sport

Logo: Dedication to a team or business,
or even an app or software program

Food: A joy of baking, cooking, or eating!

Buttons or switches: From a camera
or machine used often

Materials and textures: In their original form
(like a plant) or incorporated into a design (like
leaf patterns inside or behind another form)

Think about the equipment you use for your passion
or hobby, any special lingo and how it makes you feel,
perhaps your club name or elements from its logo (if
you'd like to use a direct logo be sure to ask first).
You could design matching tattoos for your running
club or to celebrate a milestone. You could also use
tattoos to help rekindle a passion or remind yourself
of things you'd like to do more of.

Sound waves

You can use sound waves to show your love of music. Customize by using a computer or web program to record your own.

Classic card

A classic illustration for cardplayers. Personalize by adding text to the banner.

Bicycle

This retro bicycle would be great for cyclists. Use on its own or as an element in a larger design.

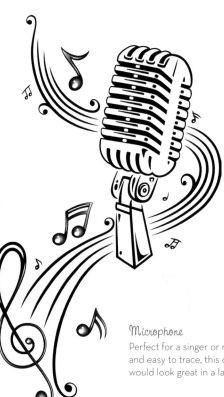

Cupcake
Share your love of baking with this adorable cupcake.

Microphone
Perfect for a singer or music lover and easy to trace, this design would look great in a large size.

Floral camera
This camera with roses is sweet and feminine.

bit.do/770637

Barista

Take your love of coffee to a new level with this barista design.

bit.do/770638

color me in

Jazz

Jazz players in an abstract cubism style.

Tennis

A pencil sketch design for lovers of tennis.

Lovers' teacup

A cute teacup for tea lovers.

bit.do/770639

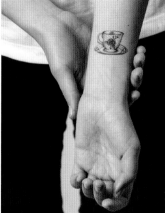

Sloth

A design for lovers of slowness and donuts, this cute sloth would be great in a medium size.

bit.do/770640

Music amp

Sketch-style music equipment would be perfect for a musician.

Yarn love
Show your love of knitting
with this sweet yarn heart.

Reading collection
Wear your love of books and
reading with a book, or two, or lots!

color
me in

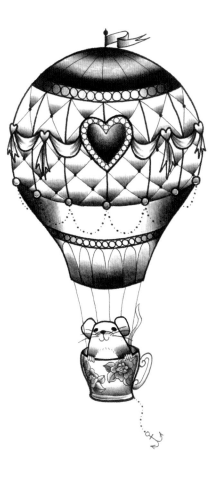

Teacup mouse
Another teacup—this time it's
incorporated as the basket in
a whimsical hot air balloon.

bit.do/770642

Stars & celestial

Celestial tattoos are often beautiful, otherworldly designs that remind us of the majesty of life, the universe, and everything. A star or celestial tattoo could be as small as a dot on your wrist, or a cosmos wrapping around your shoulder; they can fit all sizes and placements and can be easily incorporated into other designs. Consider a favorite constellation or perhaps your zodiac stars; the phases of the moon can make for an interesting pattern, and the alignment of the planets can be a metaphor for fate and our place in the world.

Meanings

Moon: Quiet, hidden, and powerful part of our psyche, attraction

Stars: Possibilities, beauty, goals, dreams

Zodiac constellation: The attributes of that zodiac star sign

Planets: The universe, fate, our path through life

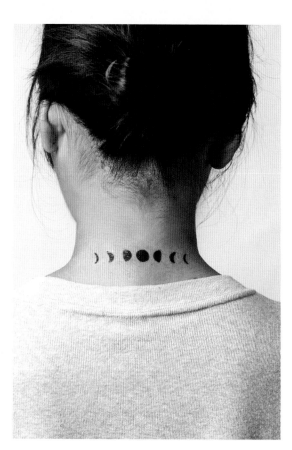

Moon phases
A simple design showing the phases of the moon.

Aries Taurus Gemini Cancer

Leo Virgo Libra Scorpio

Sagittarius Capricorn Aquarius Pisces

Constellation
Find your zodiac constellation. This could make a simple, stylish design, or incorporate it with other elements for something more complex.

Heart of the universe
All the universe in a heart shape. This would look sweet in any size.

Celestial
This whimsical illustration uses celestial themes and geometric patterns.

bit.do/770643

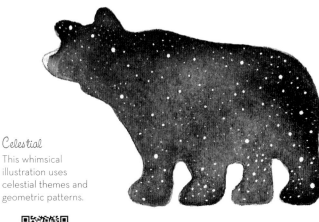

Sky at night
The night sky encapsulated within a bear outline.

bit.do/770644

Dating back to the 16th century, nautical tattoos on sailors are one of the oldest tattoo genres and are still popular across cultures. Early nautical tattoos identified a sailor's position on the ship, journeys and miles traveled, as well as being good luck talismans and amulets. Many have been adopted with modern interpretations. You might like to pick a nautical symbol that resonates with you and combine it with other elements like banners, frames, or figures in a composition.

Meanings

Mermaids: Seduction, playfulness, legend

Anchors: Stability, faith, steady passage

Ships' wheels, compasses: Direction in life, faith, reaching goals

Ships: Journey through life, home

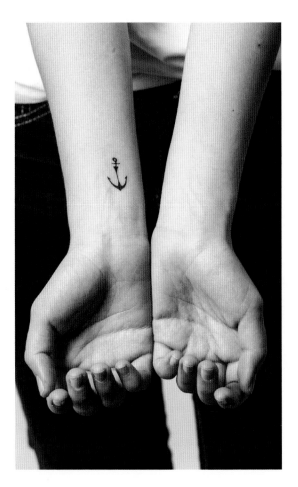

Simple anchor and ship's wheel

These stand for direction and stability, and are simple enough for tiny sizes.

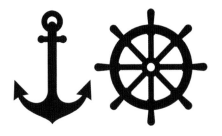

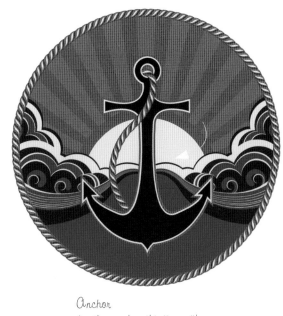

Anchor

Another anchor, this time with waves, sun, and rope. Good for medium sizes.

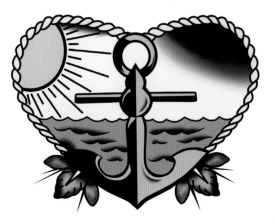

Anchor heart

An anchor in heart with waves and sunshine suitable for small to medium sizes.

bit.do/770645

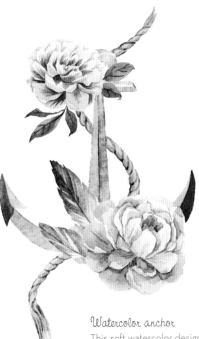

Watercolor anchor

This soft watercolor design is sweet and feminine, and would suit a large tattoo on a thigh or shoulder.

Nautical

City whale

This whale with city skyline would be great in medium and large sizes for forearm or chest.

bit.do/770646

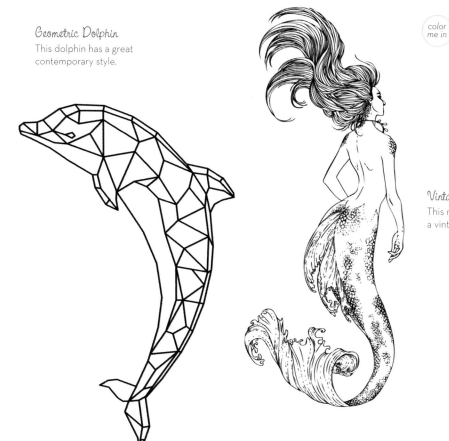

Geometric Dolphin

This dolphin has a great contemporary style.

color me in

Vintage Mermaid

This mermaid is traced from a vintage book illustration.

Ship anchor
Simple ship drawing with patterned waves.

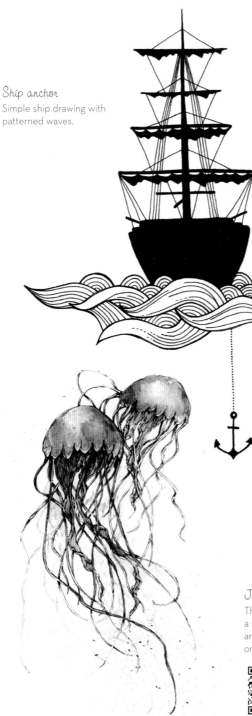

Vintage ship*
This classic tattoo subject would look best in a medium size.

Jellyfish
These jellyfish are set against a striking watercolor background and would look great on a leg or forearm.

bit.do/770649

Places & travel

A tattoo design can commemorate the places you've been, where you're from, the place you call home, or your love of travel. Apart from landmarks and text, a place can also be represented by a country or state's official flower, native animal, or a natural resource it is known for; or by a symbol that represents it only to you and has context within your own personal experience. You could also use constellations only visible from certain parts of the world, like the Southern Cross seen in the night sky of the Southern Hemisphere.

Meanings

Compass: Direction in life, taking a steady path to a destination

Map: Love of travel, continents visited, unity

Landmark: Place visited or homeland

Paper plane: Travel, freedom

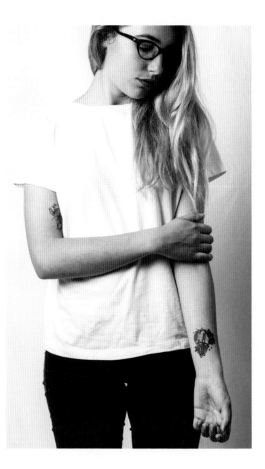

A love of travel can be represented in a design by a compass—which also symbolizes life's direction and faith—or a world map, or brainstorm related images like passport stamps. You could also incorporate more obscure references into an existing design by including points from a chartered flight path, a continent outline, or a symbol from each country you've visited.

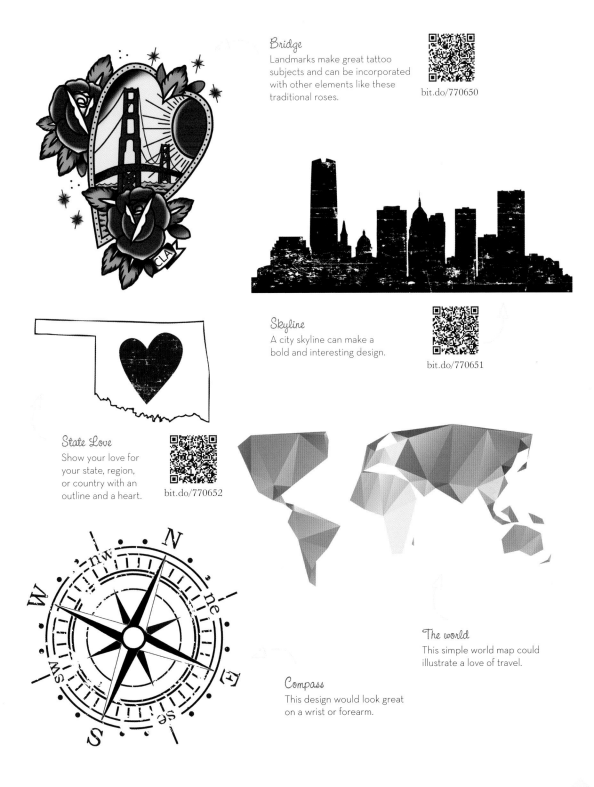

Bridge

Landmarks make great tattoo subjects and can be incorporated with other elements like these traditional roses.

bit.do/770650

Skyline

A city skyline can make a bold and interesting design.

bit.do/770651

State Love

Show your love for your state, region, or country with an outline and a heart.

bit.do/770652

The world

This simple world map could illustrate a love of travel.

Compass

This design would look great on a wrist or forearm.

Vintage

Vintage botanical illustrations—usually from vintage encyclopedias or botany studies—depict plants, flowers, and fruits precisely and often with botanical detail. Flowers and plants can be used in any number of ways to portray or express your sense of self or what's important to you. Storybook illustrations from first edition prints of classic books such as *Alice in Wonderland* use fine line work, crosshatch shading, and black ink to great effect. They can reflect your love of story characters, literature, or be paired with quotes or other design components.

Meanings

With so many subjects and illustrations available in vintage styles, you can find images of almost anything. The meanings of your vintage illustration will depend primarily on the subject—but vintage designs can also reflect a love of vintage design itself, or the vintage design style (like pointillism or line work), a particular book (in the case of vintage book illustrations), or the era that the design was originally drawn in.

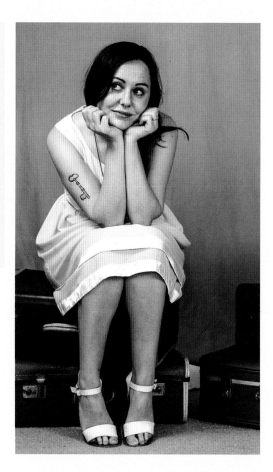

Medical or scientific illustrations usually show precision detail in black line work that complements styles like sketch, geometric, or watercolor. There's a plethora of vintage images available covering many subjects, so if you like this style, try finding a vintage illustration of your main subject matter and incorporating it into your design.

Bunny

This adorable bunny would be so sweet in a small size.

White Rabbit

This rabbit is from the original *Alice in Wonderland* book illustrations.

Regal frame

Use this frame and crown design on its own or to surround another design.

Tip

See the section on using vintage designs on p27.

color me in

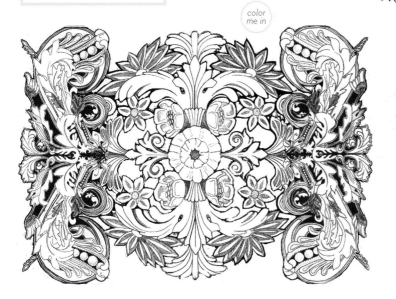

Baroque

A Baroque-inspired design great for large tattoos on the forearm or calf.

bit.do/770653

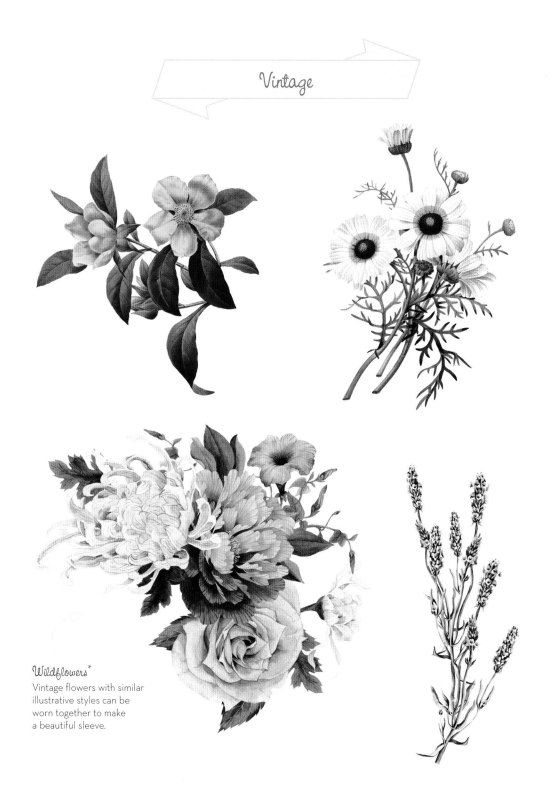

Vintage

Wildflowers*
Vintage flowers with similar
illustrative styles can be
worn together to make
a beautiful sleeve.

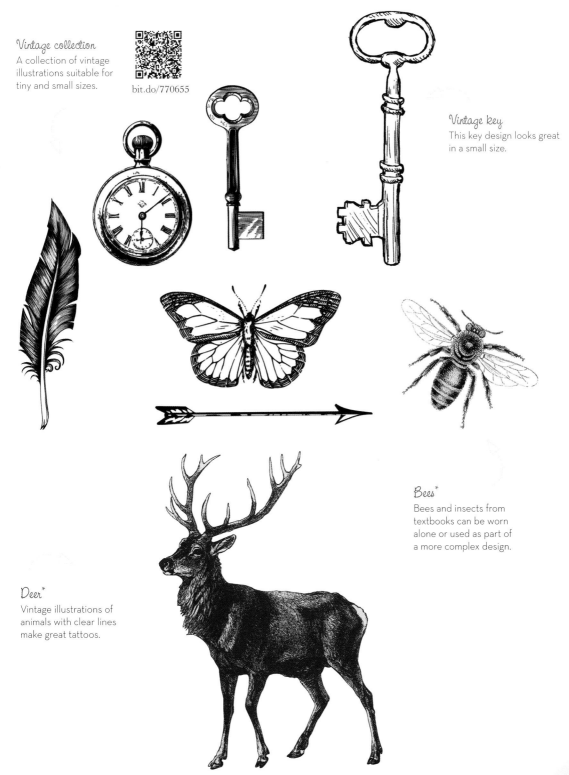

Vintage collection
A collection of vintage illustrations suitable for tiny and small sizes.

bit.do/770655

Vintage key
This key design looks great in a small size.

Bees*
Bees and insects from textbooks can be worn alone or used as part of a more complex design.

Deer*
Vintage illustrations of animals with clear lines make great tattoos.

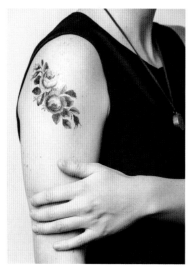

Symmetrical roses*
These vintage roses form a beautiful symmetrical design with clear line work.

Vintage flower
This black and white design would suit a wrist or lower arm, or could be added as a floral embellishment to other vintage designs.

bit.do/770659

Forget-me-not*
A classic vintage design of dogwood and forget-me-nots.

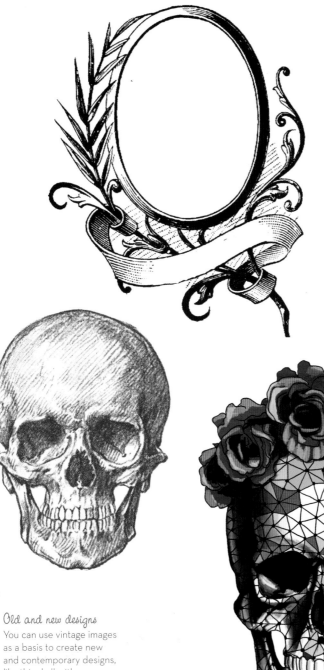

Frames
Vintage frames can be
used as an element in
your own design.

bit.do/770661

Old and new designs
You can use vintage images
as a basis to create new
and contemporary designs,
like this skull with
geometric patterns and
a floral headdress.

Geometric

Geometric tattoos refer to designs incorporating geometric elements like triangles, diamonds, dots, and repeating shapes, usually showing strong symmetry and black line work. Some subjects are made up of these shapes and lines and so lend themselves to a geometric style naturally, like subway maps, origami and circuitry, and some languages and symbols. Geometric is also considered a style, and any subject can be rendered in a geometric style. Contemporary and striking, geometric styles and subjects offer lots of options.

Meanings

Arrows: Direction in life, capable, strength

Runes: Research ancient runes for individual meanings

Circuitry: Technology, computers, robotics, mastery over machines, or intelligence

Origami: Impermanence, fragility, methodical

Diamond: Strength, value, beauty, love, resilience, purity

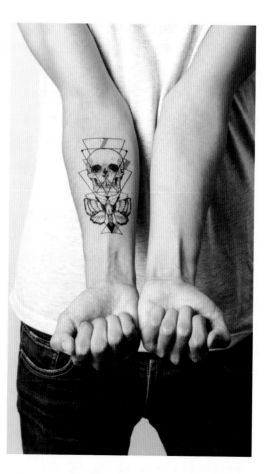

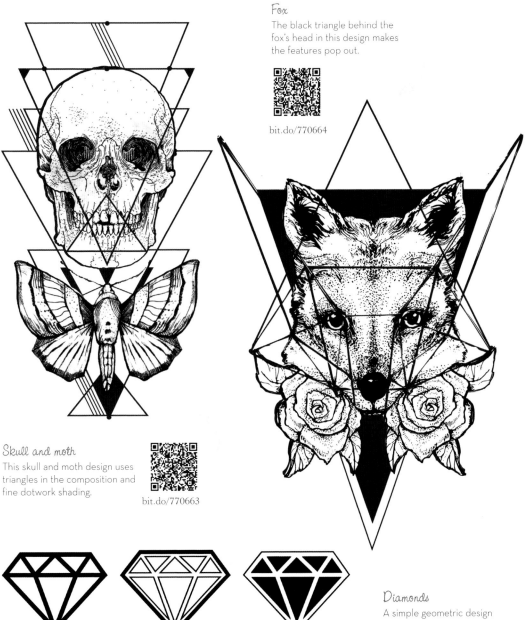

Fox

The black triangle behind the fox's head in this design makes the features pop out.

bit.do/770664

Skull and moth

This skull and moth design uses triangles in the composition and fine dotwork shading.

bit.do/770663

Diamonds

A simple geometric design such as these diamonds can be worn in tiny sizes on fingers.

Geometric pattern
This brightly colored pattern would make a simple, striking tattoo.

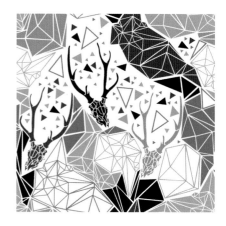

Deer and diamonds
Wear alone, or incorporate elements of this pattern into other designs.

Circuitry armband
Natural shapes and technology circuitry were the inspiration for this armband.

bit.do/770665

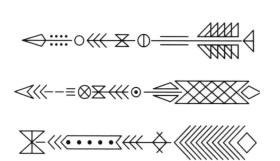

Arrows
Arrows formed with geometric patterns.

bit.do/770666

Butterfly prism
A delicate watercolor butterfly contrasts with the geometric prism.

bit.do/770667

Diamond*
This little diamond is sweet in a small size or incorporated into other designs.

Graphic Snowflake
This graphic geometric design depicts a snowflake and could be worn in a tiny to large size.

Geometric koala
This cute koala is wearing a lovely geometrically patterned sweater.

Patterns

Both a design genre and a design element, patterned tattoos can refer to designs in a pattern, such as repeating lines, or complex symmetrical shapes.

Meanings

Mandala: The universe, perfection, eternity, unity, and completeness

Repeated triangles: Mountains and obstacles to overcome

Repeated circles: Growth and focus despite various distractions

Repeated lines: Parallel lives or direction

All: Any pattern can be used as a minimalistic representation of a physical object—for example, lines on paper for a writer, curved lines representing surf, or repeated circles symbolizing buttons.

Many tattoos feature patterns to suggest a variety of textures or to create shading. Patterns can represent more ethereal subjects such as water, wind, and air; beautiful examples can be seen in Traditional Japanese designs. These kinds of patterns can be incorporated into any design, or elements can be used effectively as a minimalistic tattoo. Repeated patterns in complex, often symmetrical designs make intricate tattoos and can have spiritual meaning as well as aesthetic qualities, such as mandalas. These repeated patterns work especially well with geometric designs.

Using designs from different cultures

Many popular design subjects come from different cultural backgrounds, and it's important to understand the meaning behind your tattoo subject and not use a culture as a "trend." A bit of research and being aware of only using cultural images that mean something to you personally can make the difference between using imagery in a culturally appreciative—or insensitive—way. Understanding the cultural background and significance of imagery is both respectful to those cultures and imperative in recognizing the added meaning the use of the icons communicates within your design.

You can find out more by researching online, reading cultural and history books, and speaking to cultural elders and representatives to decide if the images within your tattoo speak to you personally, and therefore whether or not you should incorporate them.

Examples of cultural iconography include: American Indian headdresses and dreamcatchers; Mexican sugar skulls; Indian mandalas and henna designs; Australian aboriginal dot designs; and Japanese dragon and mythology designs.

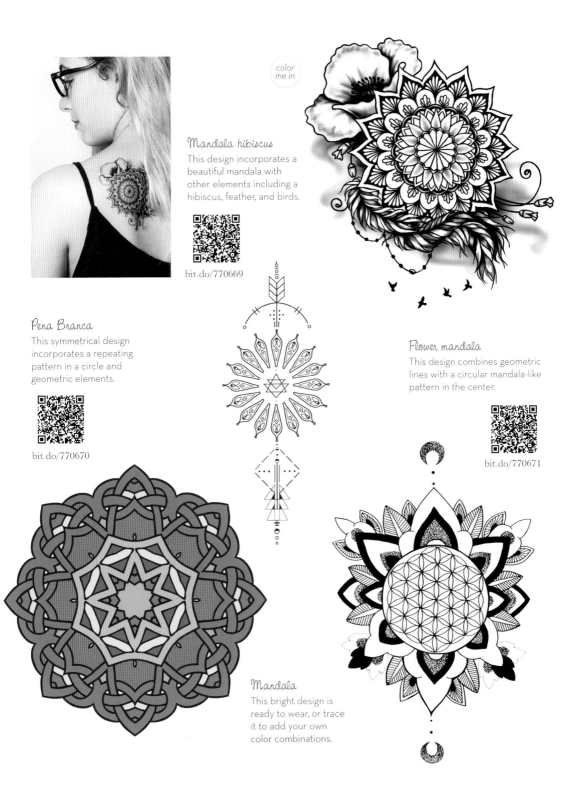

color me in

Mandala hibiscus

This design incorporates a beautiful mandala with other elements including a hibiscus, feather, and birds.

bit.do/770669

Pena Branca

This symmetrical design incorporates a repeating pattern in a circle and geometric elements.

bit.do/770670

Flower mandala

This design combines geometric lines with a circular mandala-like pattern in the center.

bit.do/770671

Mandala

This bright design is ready to wear, or trace it to add your own color combinations.

Portraits & events

Portraits are a popular choice for tattoo designs and can be created in any style and combined with limitless elements. Portraits are most effective at medium to large size to capture facial features, and are often worn on arms, legs, or chest. Portraits don't need to be confined to illustrations—they work well in multimedia styles, or use a photo of a face and combine it with illustrative elements.

Temporary tattoos can celebrate your partner, family, or loved ones and make for a great surprise! Use vintage Valentine's designs and add a message to your partner, or fool your parents with a classic "Mom" or "Dad" design.

Design a temporary tattoo for guests at your next event. Great for tattoo or photo booths, temporary tattoos are fun, memorable, and a unique way to celebrate. You could make a matching set from vintage illustrations for a themed engagement party, a selection of text designs for a bachelorette party, use a photo of the birthday girl, design something special for an anniversary event, or have all the guests wear a tattoo to surprise the guest of honor! It's a good idea to make a variety of sizes for event tattoos so everyone can choose the size and placement they prefer.

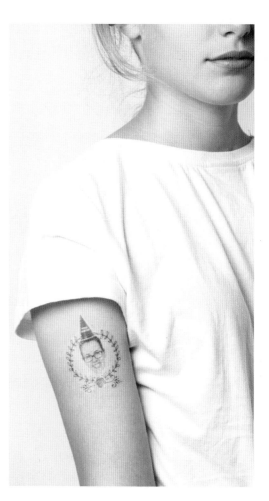

Shipmates

These matching shipmate designs are perfect for symmetrical body parts like either side of your chest, or for wearing with a friend.

bit.do/770672

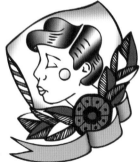

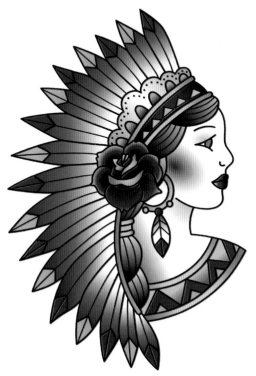

Lonely girl

Unusual line work and intricate style make this portrait unique.

bit.do/770673

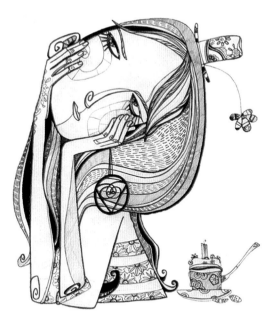

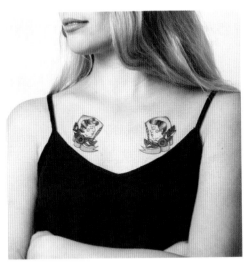

American Indian headdress

This watercolor design is an unusual portrait and would look great in larger sizes to showcase the detail.

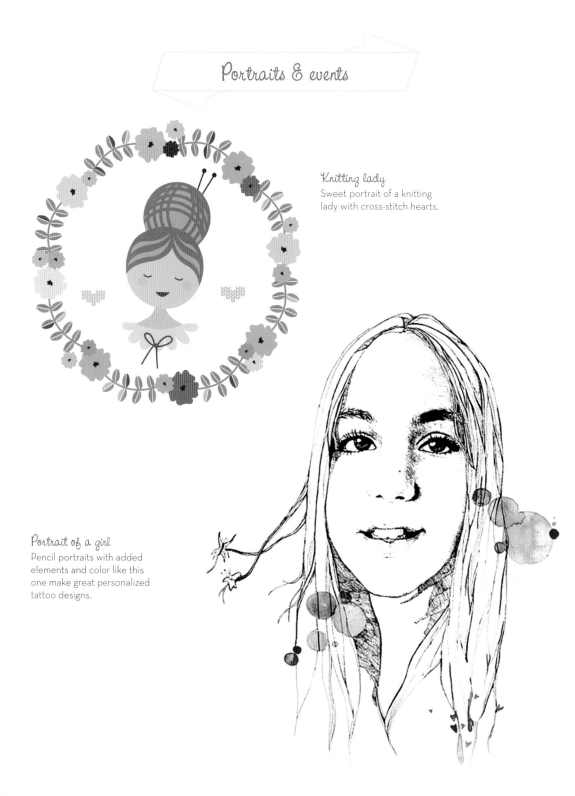

Portraits & events

Knitting lady
Sweet portrait of a knitting lady with cross-stitch hearts.

Portrait of a girl
Pencil portraits with added elements and color like this one make great personalized tattoo designs.

Father's Day

A fun Father's Day design for the most important man in your life!

bit.do/770675

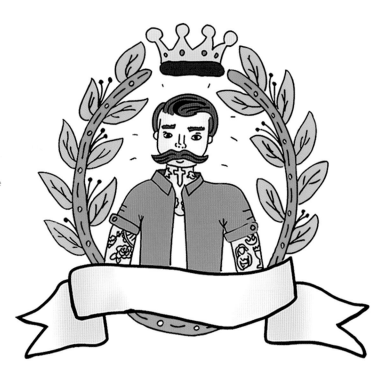

Wedding photo booth

This classic-style tattoo is a custom portrait for a wedding photo booth.

bit.do/770676

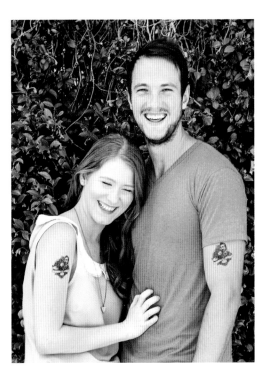

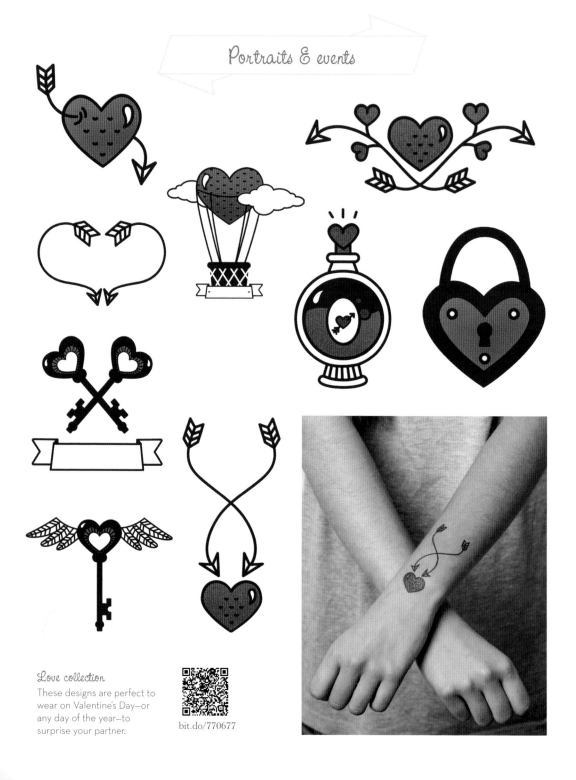

Love collection

These designs are perfect to wear on Valentine's Day—or any day of the year—to surprise your partner.

bit.do/770677

Heart and wings
This heart with wings
can be worn at any size.

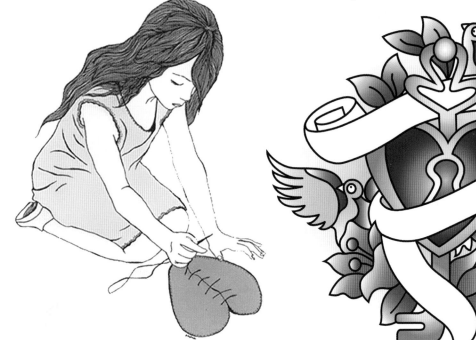

Healing
This whimsical illustration would
suit a medium or large tattoo to
capture the fine lines and detail.
© Shira Sela

Key to your heart
Either wear alone, add a
banner, or wear with the
matching designs on page 118.

bit.do/770678

Valentine heart*
Another vintage Valentine's design
perfect for adding text, incorporating
into your design, or wearing as it is.

4

Resources

Whether you're looking for an artist to create your
design, or some inspiration to create your own;
paper to print it on or someone to print it for you,
this resources section is full of links and tips to help
you create your own temporary tattoo. There are
links to graphic design programs, free fonts to use,
and online image sharing sites. Use online searches,
bookstores, and libraries to find out more; then
follow the steps in this book to design, make,
or apply your tattoo.

Happy inking!

There are many places where you can find images and inspiration for your tattoo design either online, or in books and magazines. Keep in mind that any image you find may have copyright restrictions and/or be owned by an artist or photographer, so always seek permission to use it.

Online image sharing

Online image sharing sites are an excellent source for illustrations and tattoo designs. Try looking at tattoo and art categories as well as searching for your specific subject matter. Some image sharing sites need you to register and log in to view images, others can be seen right away.

Pinterest **pinterest.com**
Tumblr **tumblr.com**
Flickr **flickr.com**
Imgur **imgur.com**

Tattoo inspiration & flash

tattooimages.biz
Gallery of tattoo photos

fuckyeahhipstertattoos.tumblr.com
Vintage style and contemporary subject matter tattoo photos

fuckyeahgeometrictattoos.tumblr.com
Geometric style tattoo photos

sacredgeometrytattoos.tumblr.com
Sacred geometry tattoo photos

inkcover.com/checkoutmyink
Gallery of user-submitted tattoo photos

tattooideas247.com
Gallery of contemporary tattoo ideas

worldtattoogallery.com
Tattoo photos by style, subject, or placement

tat-designs.com
Free printable tattoo flash designs
(ready to print or trace)

tattoojohnny.com
Huge range of tattoo flash with stencil outlines and color references

gentlemanstattooflash.com
Highest quality tattoo flash, books, and tattoo related artwork from the four corners of the globe, searchable by category

Vintage illustration websites

thegraphicsfairy.com
Vintage illustrations

vintageprintable.com
Free vintage illustrations divided into the following categories: Scientific, Naturalist, Botanical, Zoological

oldbookillustrations.com
A wide range of public domain, royalty-free images scanned from old books, with searchable galleries

reusableart.com
Vintage drawings, paintings, and illustrations from archived print materials

vintagemedstock.com
Original antique medical images, prints, monotypes, wood block prints, and illustrations

vectorian.net
Thousands of vintage vector ornaments

olddesignshop.com
Free vintage images, clip art, printables, royalty free, high resolution digital graphics

Contemporary tattoo books & magazines

Inked Magazine **inkedmag.com**

Postmodern Ink **postmodernink.com.au**

E-Volved Magazine **e-volvedmagazine.com**

Tattoo Designs: Creative Colouring for Grown-Ups
Various artists; Michael O'Mara Books Ltd, 2014

The Tattoo Colouring Book
Megamunden; Laurence King Publishing, 2015

Vintage Tattoos: The Book of Old-School Skin Art
Carol Clerk; Universe Publishing, 2009

Juxtapoz Tattoo
Juxtapoz Art & Culture Magazine; Gingko Press, Inc, 2008

Forever: The New Tattoo
Robert Klanten, Matt Lodder, and Franz Schulze;
Die Gestalten Verlag, 2012

Tattoo Johnny: 3,000 Tattoo Designs
David Bolt; Sterling Publishing Co Inc, 2010

The Tattoorialist: Tattoo Street Style
Nicolas Brulez; Octopus Publishing Group, 2015

Drawing and Designing Tattoo Art: Creating Masterful Tattoo Art from Start to Finish
Fip Buchanan; F&W Publications Inc, 2014

Pen & Ink: Tattoos and the Stories Behind Them
Wendy Macnaughton and Isaac Fitzgerald;
Bloomsbury Publishing, 2014

Temporary tattoos & custom print tattoos

Pepper Ink **pepperink.com.au, pepperink.etsy.com**

Tattly **tattly.com**

Tattyoo **tattyoo.com**

Tattoodo **tattoodo.com**

StrayTats **straytats.com**

TattooFun **tattoofun.com**

Litographs **litographs.com/collections/tattoos**

FlashTats **flashtats.com**

Tattify **tattify.com**

InkBox **getinkbox.com**

TattooYou **tattooyou.com**

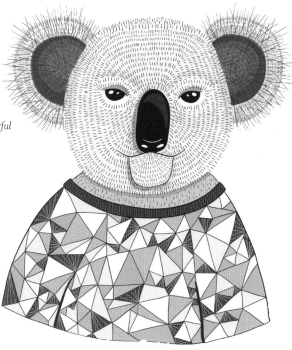

Find an artist

If you're looking for an artist to create or finish your design, check out their portfolio for styles similar to those you like and give them as much information as possible about your design and ideas.

You can find a local artist by asking at art supply stores or art colleges. Many custom print tattoo services also offer artist designs—check out their websites for more information. You can also find online artists and graphic designers on sites such as:

Upwork **upwork.com**

99Designs **99designs.com**

DesignCrowd **designcrowd.com**

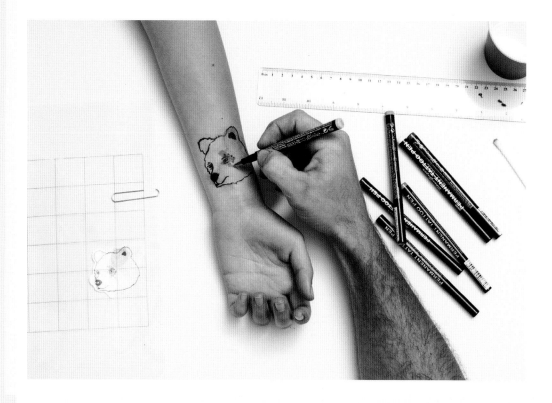

Tattoo paper & tattoo pens

See information on choosing quality paper
and the correct paper for your printer on page 50.

Go to your local craft store for face-to-face advice.
Alternatively, there's a plethora of sellers
to be found on online marketplaces such as Amazon
(**amazon.com**), Ebay (**ebay.com**), and handmade
marketplaces such as Etsy (**etsy.com**).

Free graphic design programs

These links are for programs that are free, or have
free options, at the time of publication. Check the
website for more details and information.

DrawPlus Starter Edition **serif.com/free-graphic-design-software**

Canva **canva.com**

InkScape **inkscape.org**

Paint.net **getpaint.net**

SumoPaint **sumopaint.com**

Gimp **gimp.org**

Free fonts

Dafont **dafont.com**

1001FreeFonts **1001freefonts.com**

FontSquirrel **fontsquirrel.com**

FontSpace **fontspace.com**

UrbanFonts **urbanfonts.com/free-fonts.htm**

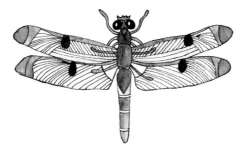

Contributors

Designers

All designs are by Pepper Baldwin or Pepper Ink Studios unless otherwise stated.

All reasonable effort has been made to contact image copyright holders. For any queries or information please contact RotoVision.

* Images have been sourced by Pepper Ink via the public domain.

Amanda Whitelaw, 49 (b), 58 (l), 67 (ml), 92 (tl) hungrydesigns.com

Anna Vartiainen, 79 (bl) annasdrawingroom.co.uk

Arrowyn Craban Lauer, 83 (br) littlegoldfox.com

Boglárka Tóth, 73 (br) facebook.com/boglarkatattoo

Carissa Rose Stevens, 69 (tl) facebook.com/carissaroseart neverdieart.etsy.com

Corbis, 43, 58 © Jutta Klee/ableimages

Dave Hooper, 72 (tl)

Deborah Panesar, 82 (bl)

Didi, 71 (tr), 78 (tl), 87 (r), 88, 90 (tr), 90 (br), 107 (br) didifox.etsy.com

Dreamstime, 31 © Jodielee

Elena Resko, 51, 54-55, 118, 119 (bl) elenaresko.com

Eliza Bolli, 74, 75 (tl)

Emma Austin, 94, 95 (tl), 96

Etsy, 99 Luminariumgraphics

Evelina Angelova, 79 (tr)

Graphics Fairy, 56, 57, 59, 75 (tm), 105 (mr), 106 (t), 111 (tr), 119 (br)

Iskra Grig Gadularova, 8, 13, 15 (br), 19, 21, 29 (tr), 37, 40, 75 (br), 78 (bl), 115 (bl), 117 (bl) behance.net/IskraGadularova

iStock, 77, 104, 106 ©Nicoolay; 107 ©etse1112

J R Hayes, 83 (bl) jrhayes.co.uk

Jenna Sue, 85 (m) jennasuedesign.com

Johan Winge, 85 (b)

Johanna DeBiase, 113 (m) johannadebiase.com

Karen Macready, 95 (bl), 99 (tl) mustdash-illustration.co.uk

Kim Geiser, 87 (bl) kimgeiserstudios.com

Kurochkina Ekaterinan (Moryachok), 20 (tr) behance.net/moryachok_art

Lisa Kirkpatrick, 84 (tl), 85 (tl), 91 (tl), 115 (t) lckirkpatrick.com

Lyn Esco, 75 (bm), 95 (br), 125 FiggyMoss.etsy.com

Manuela Pugliese (Ella), 111 (t) etsy.com/ca/shop/WhiteDoePrints

Maria Kristina Windayani, 34, 38 (b), 38 (m), 66 (tl)

Marisa Redondo, 43, 67 (br), 72 (b), 73 (tr), 77 (tl), 82 (tl) riverluna.etsy.com

May Caras, 66 (tr), 75 (bl) maycaras.com

Melinda Kovács - Sándor Haraszti, 92 (bl), 93 (bl) instagram.com/melikovacs

Mickey K, 97 (bl), 100, 101 (tl)

Nemanja Bogdanov, 8, 29 (br), 64, 67 (tl), 68 (br), 98 (tl)

Polina Smirnova, 86 (br)

Rachel Corcoran, 72 (tr) rachelcorcoran.net

Regina Quintana, 22 (t), 42, 47, 32, 42, 18, 68 (tl)

Ryan Schattner, 39 (b), 86 (bl), 86 (tr) fatmothdesign.com

Sandi Pierce, 23 (tl), 113 (br)

Shira Sela, 119 (tl) shirasela.com

Shutterstock, 17 © BeautyBlowFlow; 98 © Gluiki; 104 © Marina Grau; 104 Ola-la; 105 © AKaiser

Stella Chili, 82 (tr) printsbystellachili.etsy.com

Tiffany Atkin, 12, 23 (br), 61, 81 (bl), 124 tiffanyatkin.com

Tiffany Everett, 65 tiffanyeverett.com

Valeria Dergachova, 68 (tr), 79 (tl), 103 (bl) jinrozenrot.deviantart.com

Višnja Mihatov Baric, 18, 35, 39 (m), 68 (m), 68 (bl), 69 (br), 70, 71 (tl), 78 (bl), 99 (bl), 101 (tr), 101 (ml), 108, 109 (tl), 109 (tr), 110 (tl), 113 (tl), 116 (br)

Page 6-7
All designs appearing on these pages have been used elsewhere in the book apart from:

Fruzsi Kenez, apple fruzsikenez.etsy.com

Models

Shantell Brennan, 106; Leondro D'Ambrosio, 61; Miah Deme-Bland, 31, 67, 118; Maximillian Hesse, 15, 26, 86, 108; Rachel Kenney, 15, 70, 74, 82; Stephanie Lambourne, 7,10, 77, 117; Josue Mendoza, 12, 29, 41, 64; Sintia Othman, 15, 68, 94; Chrissie Pelser, 42; Megan Robinson, 12, 13, 40, 102; Martin Sokolinksi, 7, 117; Rocio De Stefano, 15, 18, 31, 60, 61, 84, 88, 92, 96, 100, 113, 114, 115; Cecilia Luk Wing Sze, 31, 72 All photographs are by Matthew Willmann unless otherwise stated.

Images courtesy of VectorStock.com

6 Reinekke; 10 RedKoala; 15 (tl) T-flex; 15 (mfl) lakalla; 15 (tfr) Reinekke; 15 (tr) Reinekke; 20 (bl) OlyaTropinina; 22 (b) Elmiko; 24 (tr) yuliaterentyeva; 27 krookedeye; 24 (bl) polarbearaxy; 25 i_panki; 31 (br) Reinekke; 31 (tl) Reinekke; 41 nataliahubbert; 66 (bl) Tribaliumvs; 66 (br) grmarc; 67 (b) dmitriylo; 67 (tr - collection) Favete; 69 (tr) SteveDJ; 69 (ml) YAZZIK; 71 (ml) Oksancia; 71 (bm) scorpy; 71 (br) Jenya777levchen; 73 (tl) SelenaMay; 73 (bl) paul june; 75 (tr) Leonna; 77 (bl) RedKoala; 78 (br) kois0okois; 79 (br) nadinadin; 80 T-flex; 81 (br) zzve; 81 (tl) T-flex; 81 (br) 100ker; 83 (tc) cienpies; 85 (tr) Tribaliumvs; 87 (tl) Aliasching; 89 (tr) fosin; 89 (b) W1nDkh; 89 (tl) wingnutdesigns; 90 (tl) christine-krahl; 91 (bl) lika666; 91 (mr) lhfgraphics; 92 (br) W1nDkh; 93 (tl) polygraphus; 93 (mr) Popmarleo; 95 (ml) stanok; 95 (mr) LisaAlisa; 97 (tl) nikolae; 97 (tr) GeraKTV; 98 (bl) oscarmcwhite; 101 (br) LisaAlisa; 101 (bl) onlyforyou; 102 Perysty; 103 (mr) AZZ; 103 (tr) silvertiger; 105 (tr) Perysty; 106 (m) Morphart; 109 (b) Liubou; 110 (b) Baksiabat; 110 (c) TaschiG; 110 (tr) kari-njakaBU; 111 (br) lapesnape; 111 (bl) BenjaminLion; 113 (bl) tsher; 115 (br) Reinekke; 116 (tl) MilkSilk; 119 (tl) catchmybreath; 120 onlyforyou; 123 (br) lapesnape